IMAGES
of America

ERIE CANAL

IMAGES
of America

ERIE CANAL

Erie Canal Museum
Martin Morganstein and Joan H. Cregg

ARCADIA
PUBLISHING

Copyright © 2001 by Erie Canal Museum
ISBN 978-0-7385-0869-6

Published by Arcadia Publishing
Charleston, South Carolina

Printed in the United States of America

Library of Congress Catalog Card Number: 2001091006

For all general information contact Arcadia Publishing at:
Telephone 843-853-2070
Fax 843-853-0044
E-mail sales@arcadiapublishing.com
For customer service and orders:
Toll-Free 1-888-313-2665

Visit us on the Internet at www.arcadiapublishing.com

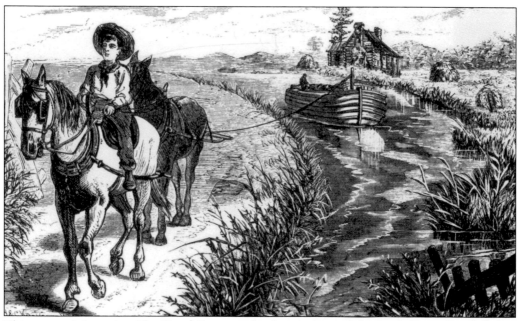

This copy of the print *The Canal Boy* was the frontispiece of the book *From Canal Boy to President*, by Horatio Alger, published by J.R. Anderson in 1881. Because of the significant impact that the Erie Canal had on American life, it was not unusual to see scenes along the canal depicted in books or in oils and watercolors at national exhibitions during the 19th century.

CONTENTS

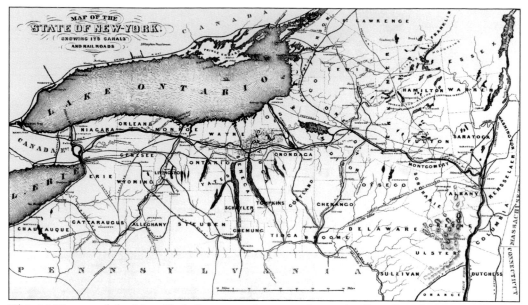

This 1859 map of the New York State canal system shows the Erie Canal, the nine lateral canals, and many of the cities and towns along these routes. (Courtesy Canal Society of New York State.)

Acknowledgments

We would like to acknowledge resources that were especially helpful to us:

Canal Boatmen, by Richard Garrity, Syracuse University Press, 1977.

The Erie Canal in the Finger Lakes Region, by Emerson Klees, Friends of the Finger Lakes Publishing, 1996.

New York State Canals, A Short History, by F. Daniel Larkin, Purple Mountain Press, 1998.

Canal Terminology of the United States, by Thomas Swiftwater Hahn and Emery L. Kemp, West Virginia University Press, 1999.

Syracuse Landmarks, by Evamaria Hardin, Syracuse University Press, 1993.

Bottoming Out, various issues, published by the Canal Society of New York State.

Syracuse: The Heart of New York, by Alexis O'Neill, Windsor Publications, 1988.

History of the Mohawk Valley, Vol. II, edited by Nelson Greene, S.J. Clarke Publishing Company, 1925.

History of Buffalo, Buffalo Evening News, 1908.

The Oneida County Historical Society.

INTRODUCTION

Dating back to the mid-1700s, well before the birth of the United States, much discussion had taken place regarding the building of a canal through the Mohawk gap in the Appalachians across New York. The great barrier of the Appalachians had confined the growth of the colonies, and then the new American nation, to the eastern seaboard. Traveling to the interior, over poor roads and trails, was an arduous time-consuming task.

A survey of a canal route that would join the Hudson River with Lake Erie was ordered by the New York State legislature in 1808 and, with the support of Gov. Dewitt Clinton, construction of the Erie Canal began in Rome on July 4, 1817. The 363-mile-long canal, with its 83 locks, 18 aqueducts, and nearly 300 bridges, cost the state of New York $7,143,789.66 and was officially opened on October 26, 1825. From the very beginning, the Erie Canal was an unbridled success. Between 1817 and 1836, nine lateral canals were built, connecting northern and southern parts of the state to the Erie Canal and the Mohawk Valley. Enlargement of the original canal, begun in 1835, was completed in 1862 at a cost of over four times that of the original project.

The expansion of the U.S. boundaries westward and political and economic events in Europe that contributed to the American immigration explosion played a vital role in the Erie Canal's success. As raw materials and agricultural products from new settlements moved eastward, finished goods and newcomers traveled westward on the canal. New York City became the young nation's major port as the flow of traffic traveled up and down the Hudson River and across the state on the canal. By 1835, cross-state travel time was reduced from four to six weeks to six days, and freight costs fell from $95 to $125 per ton to $4 to $6 per ton. Cities and towns sprang up to service this commerce and, as canal traffic prospered, so did these communities. Populations of the principal cities along the route doubled and tripled between 1830 and 1850, and businesses and industries grew to meet their needs.

The importance of the Erie Canal faded with the coming of the railroads, but not before the canal left its indelible mark on the history and heritage of New York State and the United States. The Erie Canal was there at the inception of the ever-escalating race to get from one place to another efficiently and economically, the east-west precursor of today's New York State Thruway. This book tells the visual story of the people and places that gave the Erie Canal its life.

Chapter 1, "People and Places," introduces you to the faces of the people whose lives were shaped by the canal. You see people who made their livelihoods by building the man-made waterway, operating canal boats, or running businesses that supported canal life. This chapter

takes you to places bustling with new people and new industries.

In chapter 2, "Scenes along the Canal," you travel through rolling countryside, thriving cities, and busy towns and see the canal through the eyes of 19th-century travelers. The Erie Canal ran adjacent to the Mohawk River, and you can follow its path as it wends its way through New York's beautiful Mohawk Valley and then on to the cities and towns of central and western New York.

The builders of the canal were confronted with many obstacles, not the least of which were how to cross rivers and other bodies of water, how to move people on roads that cross the canal, and how to safely navigate the waterway. Chapter 3, "Boats, Bridges, and Aqueducts," looks at the engineering feats that overcame these obstacles and, at the same time, created the civil engineering profession in this country.

The Erie Canal gave birth to some of the country's industrial giants and many small businesses, factories, and mills. In chapter 4, "Business and Industry," we visit some of the commercial establishments that depended on the canal for their transportation needs and their very existence.

The Erie Canal had its share of problems and tragedies. In chapter 5, "Disasters," we view some of the mishaps that created havoc on the canal.

The heyday of the Erie Canal has long since passed. Chapter 6, "Remnants of Past Glories," takes a look at what some of the features of the old canal look like today. Remains of the towpath, aqueducts, locks, and the canal itself remind us of the "artificial river" that helped build a nation.

The Erie Canal Museum was founded in 1962 and is housed in the former Syracuse Weighlock Building, a Greek Revival structure built in 1850 to weigh canal boats that traveled the Erie Canal through the center of the city. The museum is dedicated to telling the story of the Erie Canal and does so with a gallery full of participatory exhibits and special exhibitions that draw on the museum's nationally renowned artifact collection and historical research. The Erie Canal Museum is also the home of the Syracuse Heritage Area Cultural Park, which is designed to introduce visitors to the many attractions of downtown Syracuse and the surrounding area.

There are a number of people who helped us bring this book to realization, not the least of whom are Vicki B. Quigley, vice president of the museum board of trustees, and Andy Kitzmann, interim executive director of the museum. Both of them served as guiding lights and provided the impetus that led us to take on this project. Our thanks go to the Erie Canal Museum Board of Trustees and membership for their support. Mark Koziol, the museum's curator of collections and exhibitions, gave us his invaluable assistance in the selection of photographs and provided us with historical information when we were at a loss for words. Also, many thanks to our other staff members Steve Caraccilo, Lisa Mattes, and Anne Bourcy for being there when we needed them and to Barbara Richardson and Karen Morganstein for their assistance. Special thanks to our editor, Pam O'Neil, who said that there was no such thing as a stupid question and meant it.

One

PEOPLE AND PLACES

The Erie Canal changed the face of New York State, the United States, and the people whose lives it touched. The canal attracted construction workers, boatmen, immigrants, and the people required to support their needs. Together with their families, they created cities, towns, and villages. In this chapter we will introduce you to some of the folks who lived their lives along the Erie Canal.

Life on the Erie Canal was a jumble of people and boats traveling through the many places from Albany to Buffalo. All quite different, the lives of the passengers and of those working on and along the canal are opened to us through the photographs. View the many faces of the people on the canal, posing for posterity, often putting on their best face. Yet, we can still draw from them a clear sense of canal life. The photographs take us back to the 19th century, to a time when work was labor intensive, when animal power was just giving way to new technologies. Seen together, the images reflect the variety and breadth of life along America's "artificial river."

Come with us now as we travel the old Erie Canal.

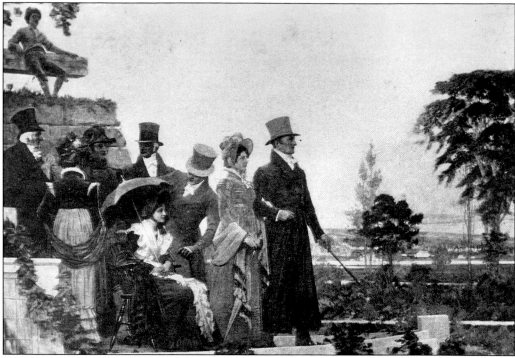

A 1905 painting by C.Y. Turner depicts Gov. Dewitt Clinton and his party aboard the *Seneca Chief* in Buffalo on October 26, 1825. The painting commemorates the beginning of Clinton's journey on the just completed Erie Canal, now joining Buffalo with Albany and the Hudson River and down to New York City.

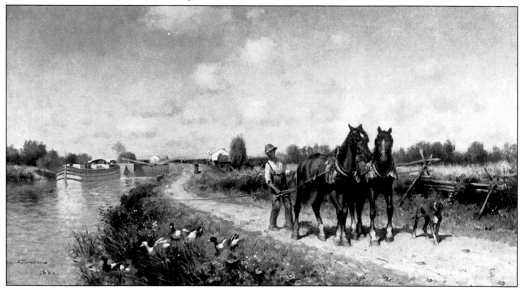

A.W. Thompson painted *Life on the Towpath* in 1881. The Canajoharie Library and Art Gallery owns the original painting. This painting illustrates the popular notion of canal life. The canal boat is traveling through an agricultural area, having just left the lock in the background. The hoggee drives his team, while the dog prances nearby. Everything is in bloom in this serene picture of the times.

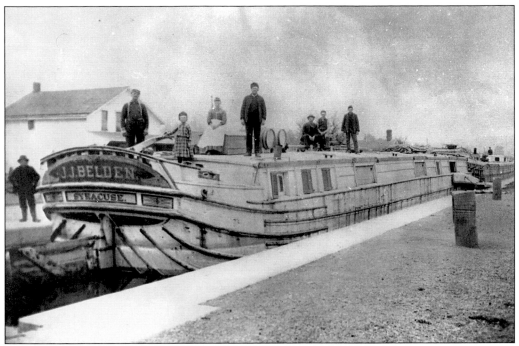

A bullhead boat, the *J.J. Belden,* is locking through at an unidentified location on the Erie Canal. A bullhead had a blunt, rounded bow and stern and a cabinlike cover running the length of the boat to protect perishable cargoes such as flour or grain.

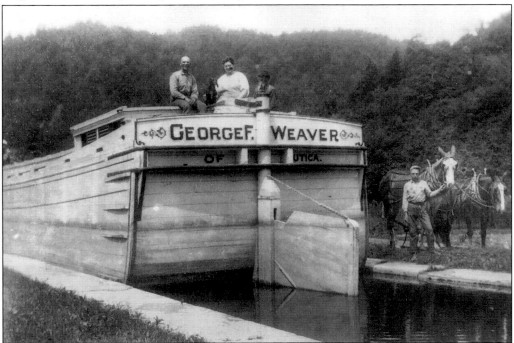

The *George F. Weaver* of Utica locks through at an unknown location. Boats, on an average, could navigate on the canal for just over seven months of the year—from the first spring thaw to the first winter freeze.

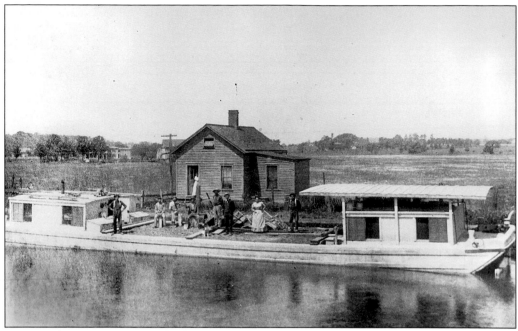

A repair boat, commonly called a hurry-up boat, is docked near the center of Weedsport c. 1905. The cook, Minnie Manwaring, is on the barge. Her husband, with hands on hips, is standing to the left. The Caywood farm is in the background.

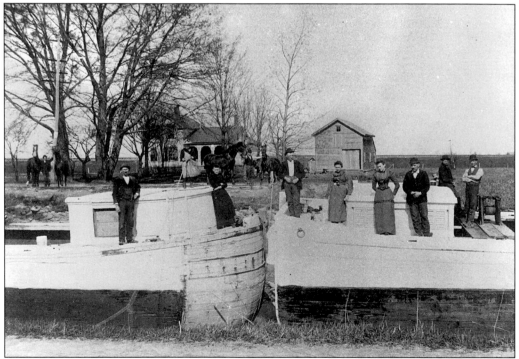

Two mud-larked boats await spring waters in the canal at Canastota. The canal was closed in winter and drained for necessary repairs. Boats not in dry dock ran the risk of becoming grounded in the mud until the spring reopening, hence the phrase "mud-lark."

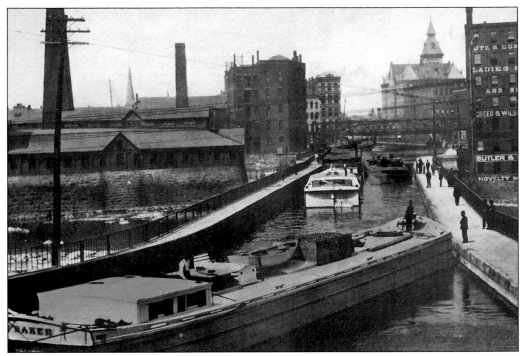

This photograph shows a canal boat navigating the curve on the Genesee River Aqueduct in Rochester. The aqueduct took the canal over the river. A lift bridge is in the background. As with any mode of transportation, spectators take a minute to watch the difficult maneuvering of the canal boats.

The *William Newman*, the first steam canal boat used on the Erie Canal, is docked at Central Wharf in Buffalo in 1880. The *William Newman* made the 345-mile trip from Troy to Buffalo through 72 locks in 4 days, 22 hours.

70 miles a day average

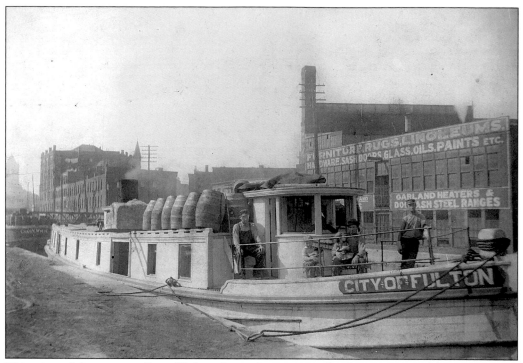

This view of the steamer *City of Fulton* shows that every inch of space was used for transporting cargo. The barrels located on the top also indicate the relatively smooth ride experienced on the canal. It was not unusual to see whole families working the boats on the canal.

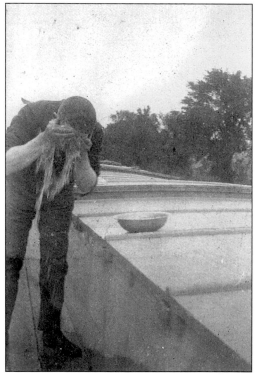

This young man washes up on an unseen canal boat. The bowl of water would not have been collected from the canal, but from a barrel of fresh water on board.

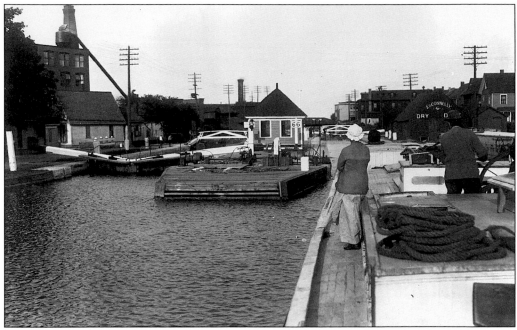

This photograph was taken from the stern of a canal boat as it approached Lock No. 66 in Rochester. A canal freighter was usually the floating home of the captain and his family. The captain's wife had a small compartment in the stern that served as her house. Clothes were washed in the canal and rigged over the cargo to dry.

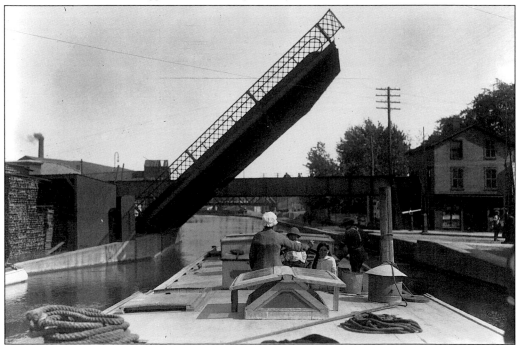

In this photograph, the woman has moved to the steering wheel of the boat and is steering the boat through the middle of the channel. The captain, his wife, or a hired hand usually operated the boat.

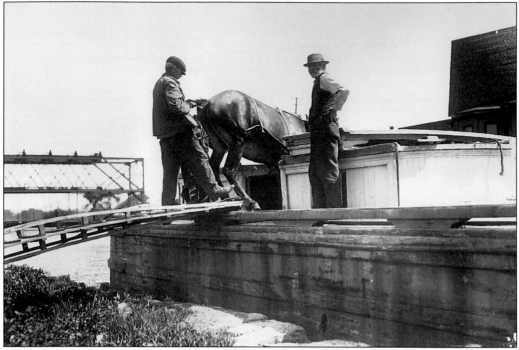

At the end of their six-hour shift, mules were sometimes stabled on board. This man is stabilizing, or "tailing-on," the mule while it boards. While on board, mules rested and were fed and watered.

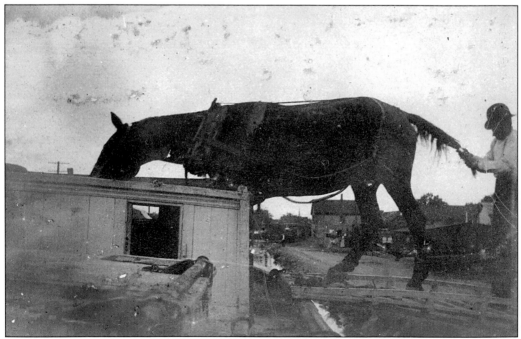

Here, a hoggee is tailing-on his mule. Horses or mules that were led by drivers, also known as hoggees (believed to be from the Scottish word for worker), drew canal boats. The hoggees were responsible for the feeding and caring of the animals and earned about $10 a month.

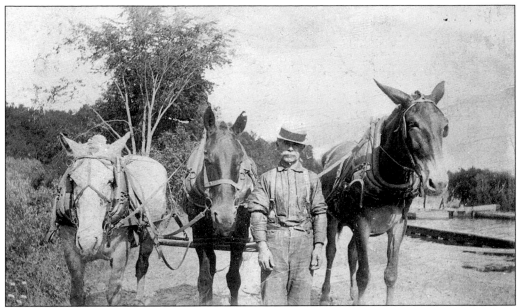

Mules were of varying sizes and colors, depending on their lineage. The offspring of a female horse and a male donkey, they were preferred over horses because of their natural stability, their tendency not to overeat, and their refusal to drink polluted water.

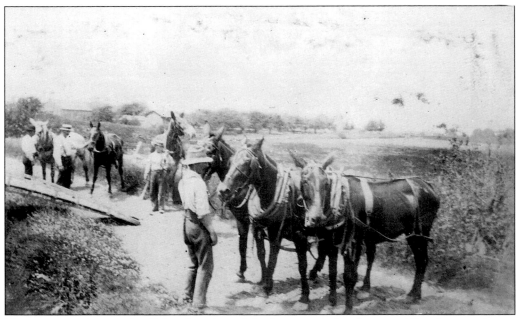

Here we see an example of the changing of the hoggees and mule team. The three mules on the left await tailing-on the boat. The team on the right is beginning its six-hour shift, while the other team is rested, fed, and groomed.

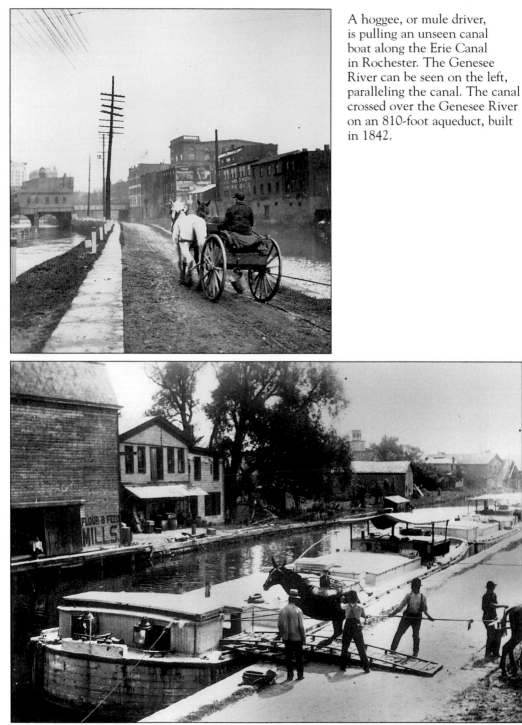

A hoggee, or mule driver, is pulling an unseen canal boat along the Erie Canal in Rochester. The Genesee River can be seen on the left, paralleling the canal. The canal crossed over the Genesee River on an 810-foot aqueduct, built in 1842.

Since the canal was closed during the winter months, hoggees were generally unemployed during that season. There is a story about two young hoggees who walked into a canal town court early in December 1870 and asked to be sent to jail until the canal reopened in the spring. As far as we know, the court obliged.

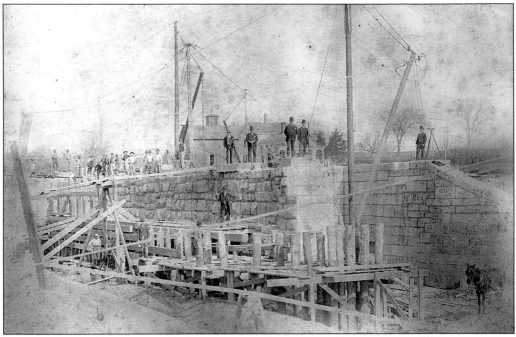

Several men pose at the construction site for Lock No. 60 in Macedon on April 27, 1888. The stone wall of this lock can be easily seen. Heavy stone was set in place, either by a hoisting machine or by the use of rollers placed near the wall. The pattern of this wall appears to be what was referred to as regular course rubble.

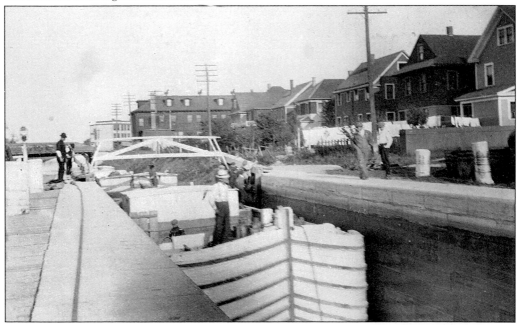

Often boats had to wait their turn to enter a lock. These boats are approaching a lock from the east at an unidentified location on the Erie Canal. Prior to the canal's enlargement, beginning in 1835, canallers had to contend with single locks that allowed only one boat through at a time, creating greater traffic jams.

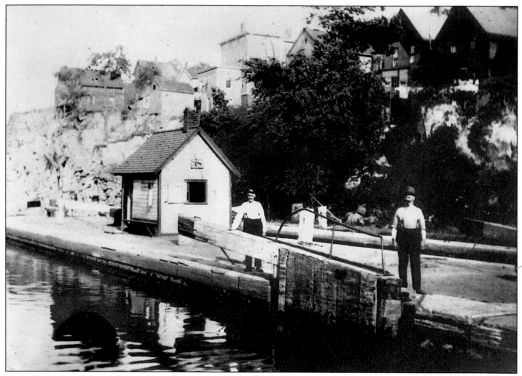

Locks were used to raise or lower canal boats from one water level to another. Locktenders were responsible for the care and operation of the locks. These locktenders are at Lock No. 38 in Little Falls.

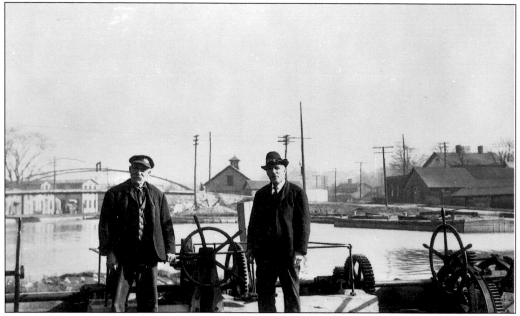

As the 20th century dawned, lock operation became increasingly mechanized. These locktenders, Messrs. O'Brien and Jackson, operated the Lodi Locks in Syracuse in 1917, the last year of operation for the old Erie Canal.

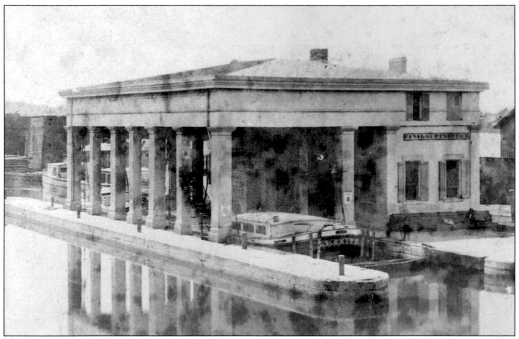

This is a photograph of a canal boat in the Rochester Weighlock. After the boat entered the chamber, the lock gates were closed, the water was released from the chamber, and the boat was lowered to a wooden cradle that was attached to the weighlock scale. Captains paid tolls based on the weight of the cargo and destination of the boat. After weighing, the lock chamber filled with water and the boat moved out. If all worked well, the weighing process could be completed in 15 minutes.

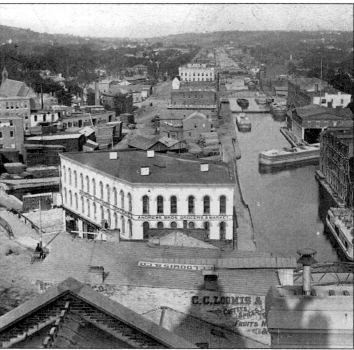

A canal boat is leaving the Syracuse Weighlock c. 1878. The Erie Canal ran through the center of Syracuse. This view looks east from downtown Syracuse. In 1841, there were weighlocks located at Albany, West Troy, Utica, Syracuse, and Rochester. The pay of the five weighmasters and their assistants amounted to nearly $5,400 for the 12 months ending on September 30 of that year.

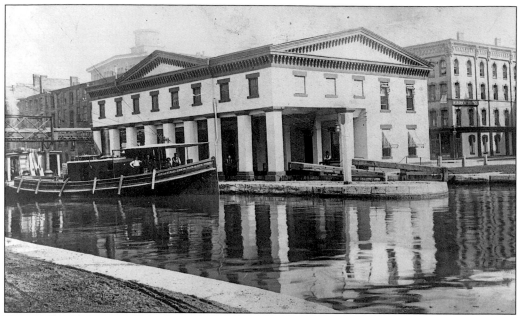

Eventually there were seven weighlocks along the Erie Canal. These buildings were used to weigh canal boats to determine the appropriate tolls. Tolls were discontinued in December 1882, making weighlock buildings obsolete. Pictured here is the Syracuse Weighlock Building, c. 1903, now the home of the Erie Canal Museum.

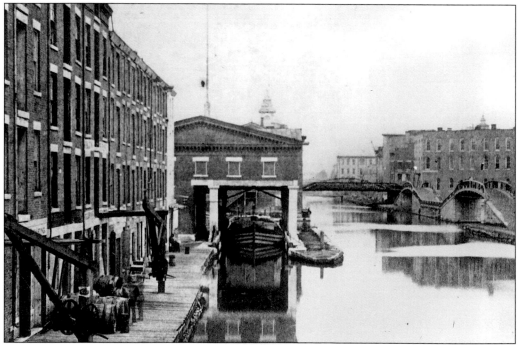

This c. 1870 view looks west down the Erie Canal, with a canal boat in the Syracuse Weighlock. The junction of the Oswego Canal is at the towpath bridge, on the right. The Warren Street Bridge crosses the Erie Canal, in the background. The buildings in the left foreground house commercial establishments today.

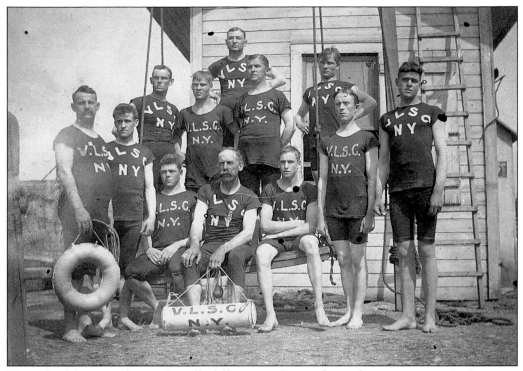

The risk of drowning by accidentally falling into the canal was always a concern. In Syracuse, a volunteer lifesaving corps, shown here in the 1890s, took its job very seriously.

In this picture, members of the volunteer lifesaving corps are shown practicing their skills. At the Syracuse Weighlock on July 5, 1866, the wife of Lewis Rushmore, captain of the *Union*, lost her life when the tiller of the boat knocked her and another women overboard. Mrs. Rushmore, who was forced under the weighlock cradle, drowned before she could be rescued.

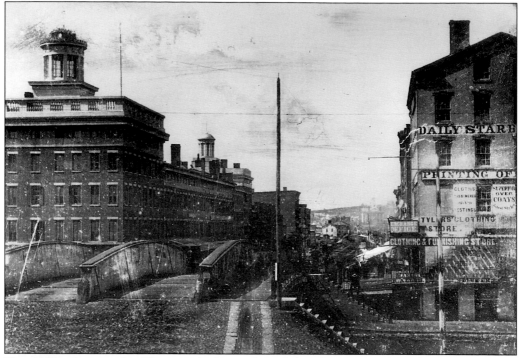

This 1850s photograph of Syracuse looks north on Salina Street over the Salina Street Bridge. The Erie Canal made the center of the city the core of banking and other commerce.

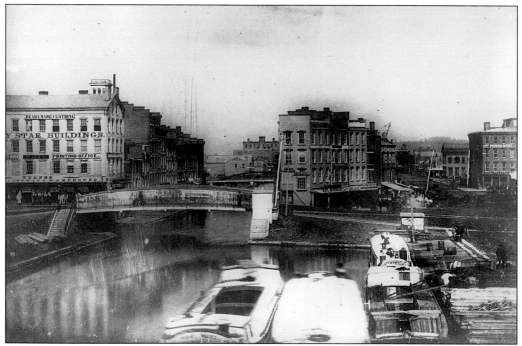

The Erie Canal ran through the center of Syracuse and crossed the main street, Salina Street, at Clinton Square. This *c.* 1854 photograph looks east toward the Salina Street Bridge. The Daily Star Building is on the left. The Coffin Block, in the center, housed several retail establishments.

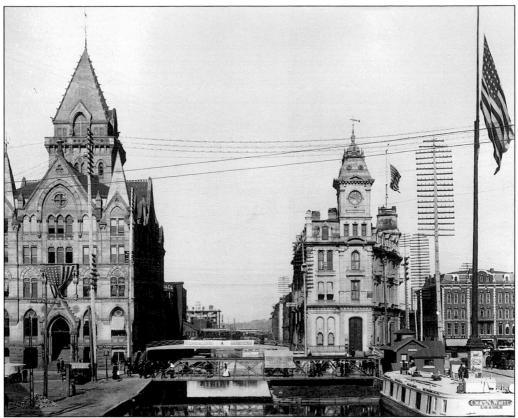

This same view of Clinton Square *c.* 1890 shows economic changes brought about in large part by the Erie Canal. In 1875, the Syracuse Savings Bank Building replaced the Daily Star Building, and the Gridley Building, built in 1867, replaced the Coffin Block.

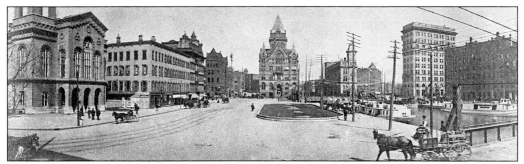

This early-1900s view of Clinton Square in Syracuse looks straight at the Syracuse Savings Bank Building. The Onondaga County Savings Bank Building, built in 1897, is the taller building on the right. Banks along the Erie Canal were the repositories for the local toll collections, which greatly enhanced the economic development of each area along the canal.

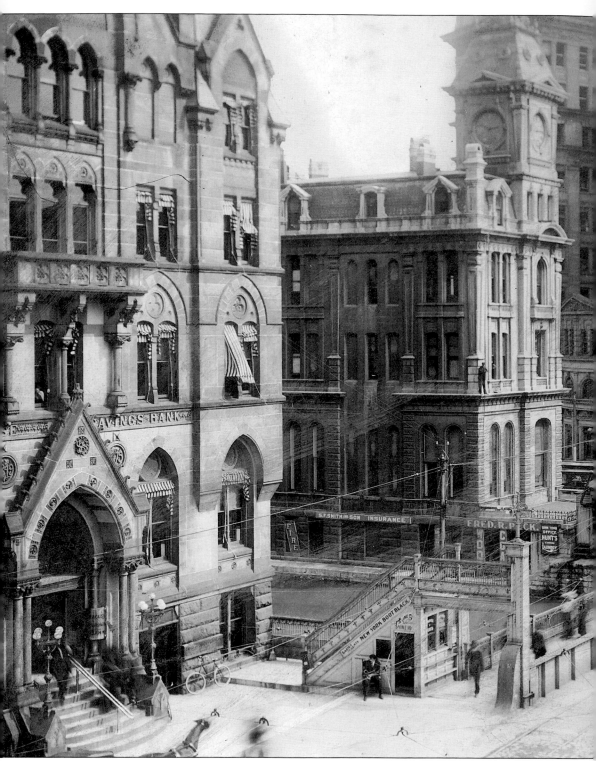

This *c.* 1910 view looks south down Salina Street in Syracuse. The stairs on the right and left sides of the street allowed pedestrian traffic to cross the canal when the bridge was in the lift

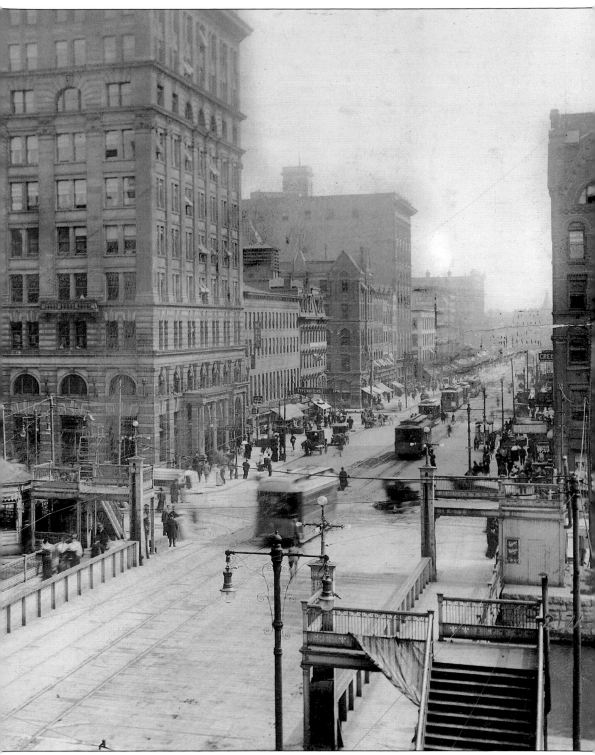

position for passing canal boats.

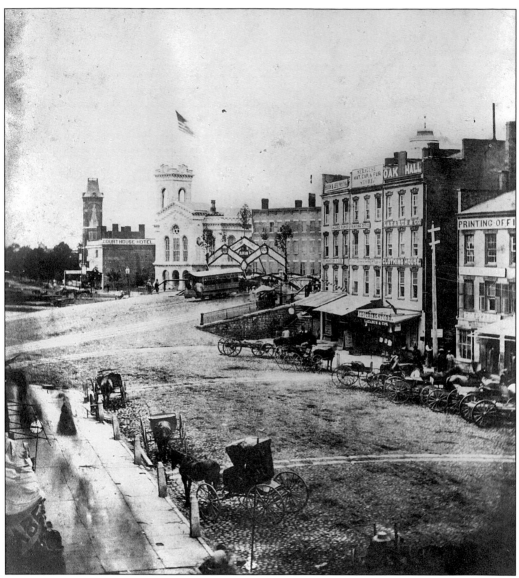

Soldiers returning from the Civil War in 1865 were greeted by these decorations above the Salina Street Bridge, over the Erie Canal. The photograph looks west across Hanover Square in Syracuse toward the Onondaga County Courthouse.

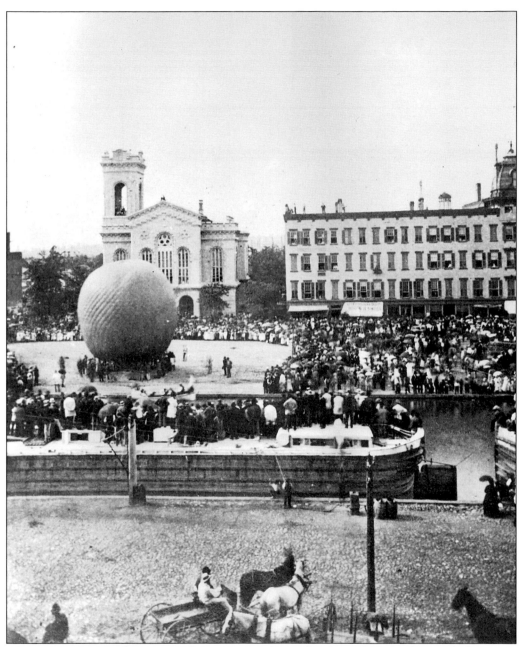

Clinton Square was the center of attention in the mid-1870s, when this hot-air balloon was launched. On this occasion, canal boats afforded onlookers "the best seat in the house."

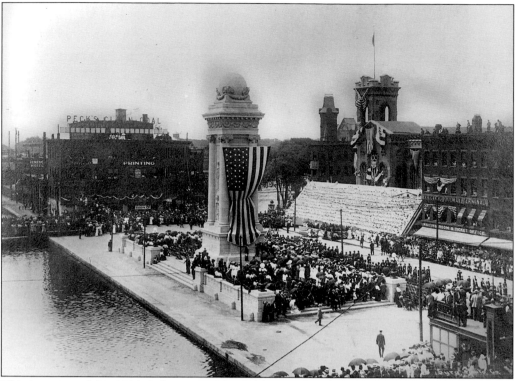

This is a view of the 1911 dedication of the Soldiers and Sailors Monument at Clinton Square in Syracuse. With all the people surrounding the monument, even on the bridges, it is surprising that there are no canal boats in this picture.

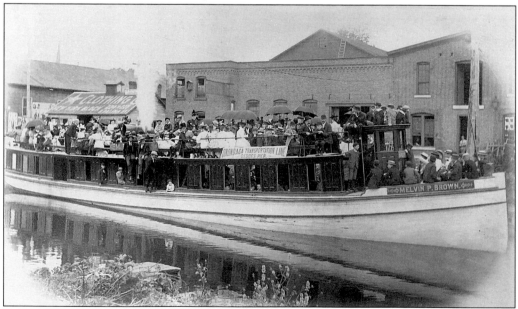

The steamer *Melvin P. Brown*, built in Baldwinsville by Captain Brown, is brimming with passengers and ready for an excursion on the Erie Canal. The Morris Machine Works building is in the background.

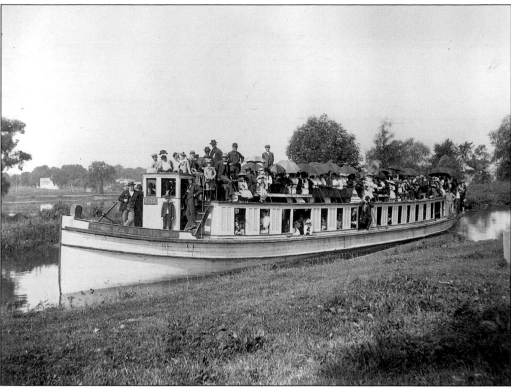

Weekend excursions were a popular pastime on the Erie Canal. The *William B. Kirk* is overloaded on a hot summer day *c*. 1890. Packet boats were usually 60 to 70 feet in length. It was not unusual for packet boats to provide a dining room, a library, and carpeted and curtained sleeping quarters for the women.

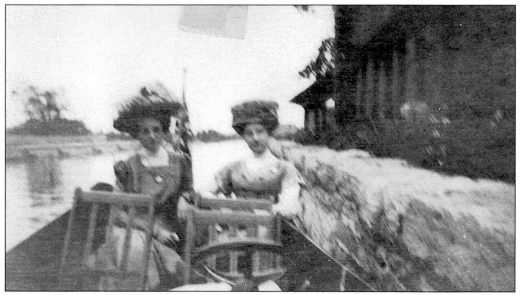

Here, two well-dressed women, ready for a short excursion, sit aboard a small boat owned by Albert L. Zysset. Not all the traffic on the canal was bound for long-distance travel.

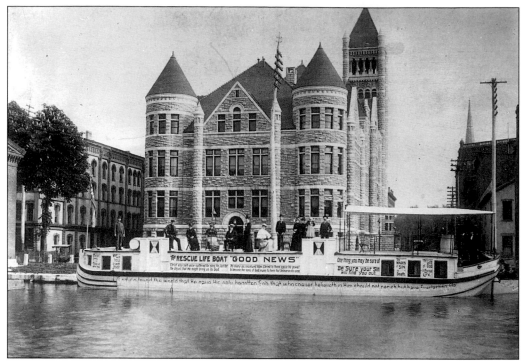

The Syracuse Rescue Mission, founded in 1857, sponsored the *Good News* to serve spiritual needs by cruising the canal to Utica, Oswego, Buffalo, and Jordan. The boat, supported entirely by voluntary contributions of money and foodstuffs, cost about $1,200 a year to operate. The *Good News* is shown here at Market Square in front of the Syracuse City Hall in 1893.

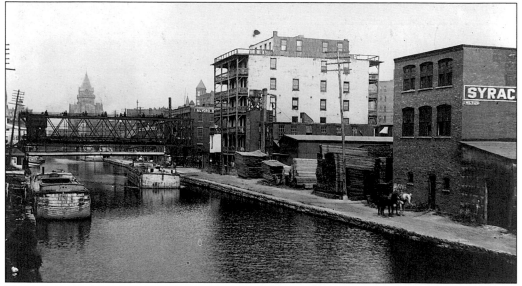

This view is looking west near State Street in Syracuse. The two-horse team is pulling a canal boat east under the State Street Lift Bridge. During the days of the original canal, State Street was known as Lock Street because the Syracuse Lock was located where the moving boat is in this picture. The Syracuse Savings Bank tower, which can be seen in the background, and the lumberyard near the towpath are good examples of businesses that located along the canal.

Two

Scenes along the Canal

The 363 miles along the route of the canal from Albany to Buffalo afforded the traveler varied views of rolling countryside along the Mohawk River, the valleys of Central New York, and the nearly 70-foot rise of the Niagara Escarpment. Being pulled along at up to four miles per hour must have given the voyager ample time to enjoy the passing landscape.

The canal passed through villages and towns such as Cohoes, Rotterdam, Palatine Bridge, Stacy's Basin, May's Point, Greece, Eagle Harbor, Gasport, and Tonawanda. Each settlement must have had its own unique story.

As the reader progresses through these next photographs, scenery of the canal and its perimeter are the focus. The water—natural and artificial—the landscape, and the forestation are magnificent. The homes, farms, and businesses that group or string along the canal indicate the presence of a growing and vibrant population. The canal's infrastructure, with its aqueducts, locks, bridges, and towpath overlaid on the majestic countryside, makes the photography memorable. Whether taken from hillsides or at ground level, the photographs capture the canal and its environs. The photographs in this chapter are intended to give you a taste of what it was like to travel on the Erie Canal.

Welcome aboard!

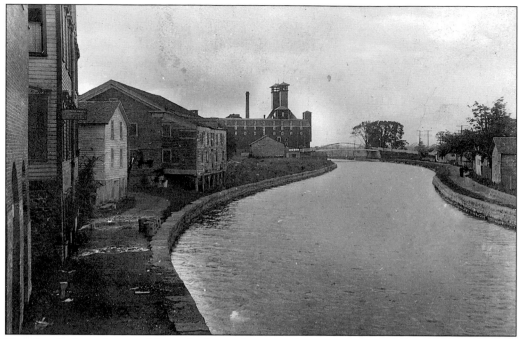

Here is a look at the canal from the hoggee's point of view as the canal makes a turn through the village of Jordan. A Jordan resident was quoted as saying that the canal was the main street of the village and the lifeline, which reached from the east to the newly developing western territories by way of the Great Lakes. Today, portions of Aqueduct No. 8 may be seen in the village, which also maintains a village canal park.

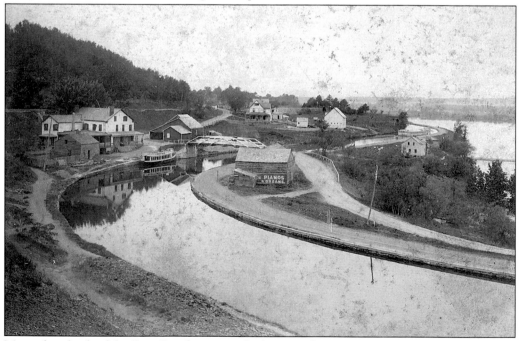

Most of us think of the Erie Canal as a straight-line canal. Here is an example of an S-curve of the canal as it paralleled the Mohawk River. A canal boat is tied up just before the bridge.

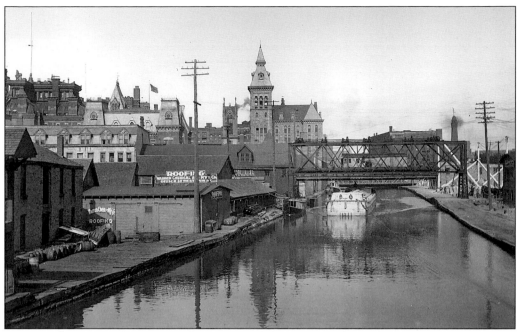

Here we are in Rochester, watching a canal boat approaching the Warren Chemical & Manufacturing Company. At a maximum four miles per hour, there was very little wake created by the canal boat's forward motion. (Courtesy Museum of Arts and Sciences, Rochester.)

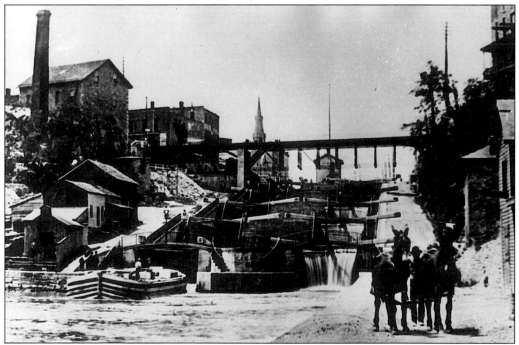

Along the original canal, Lockport was an unusual sight. There were five eastbound locks alongside five westbound locks to take the boats through the 70-foot elevation change of the Niagara Escarpment. Walking the mule team through this lock configuration must have been a challenging job for the hoggee.

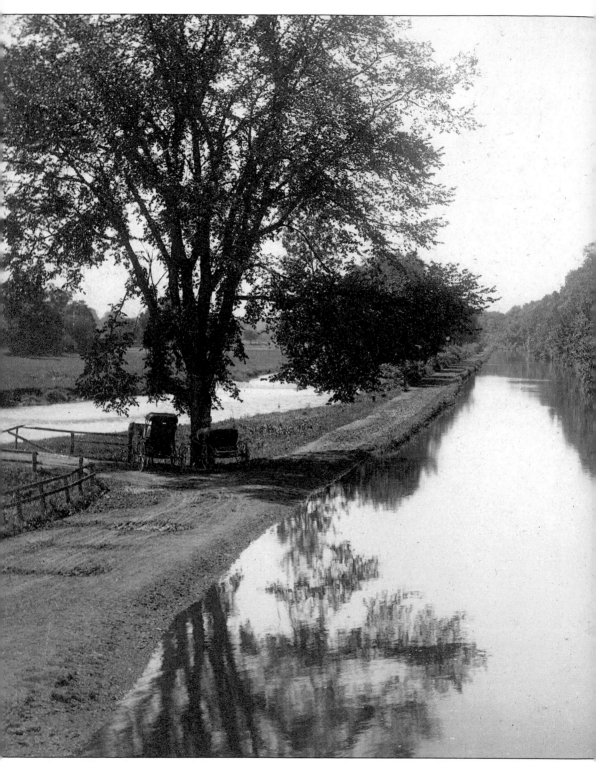

It would have been quite pleasant on a sunny summer day to find yourself at the bow of a canal boat looking at this view. An early traveler commented on the beauty of the natural landscape

and the calm and serenity of the artificial waterway as the boat glided along.

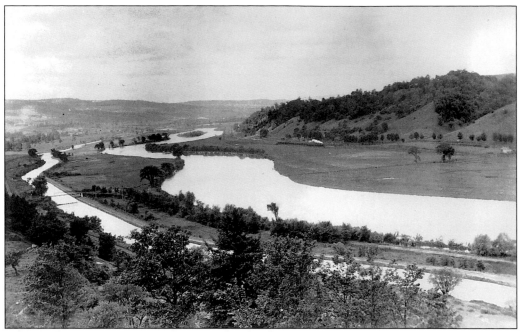

This photograph, looking west, shows the Erie Canal running parallel to the Mohawk River through the Mohawk Valley of New York. You can see the towpath on the north side of the canal. Note the railroad train in the center of the picture.

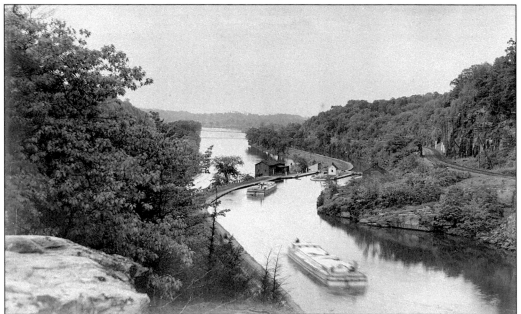

Two canal boats approach locks at an unidentified location along the Erie Canal. The Mohawk River parallels the canal on the left. The second boat will have to wait while the first boat locks through. To stop boats pulled by animals, a boatman had to attach a short rope to the bow of the boat, jump ashore, and wrap the other end of the rope to a post or cleat on the shore. There were posts every 25 feet, allowing the boatman to move from post to post, slowing the boat. This process was known as "snubbing."

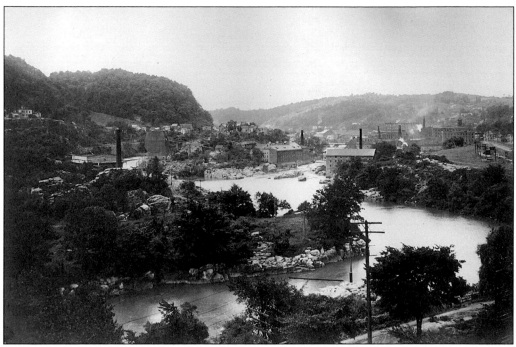

Little Falls is a famous geologic place where a very small area between the surrounding mountains exists. In this photograph the village, the Erie Canal, and the Mohawk River all converge in that small area.

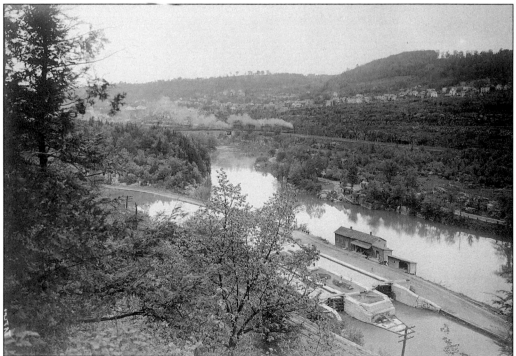

Another view of Little Falls, taken in 1902, shows the city, the lock, the Mohawk River, the road, and the steam railroad from a different perspective.

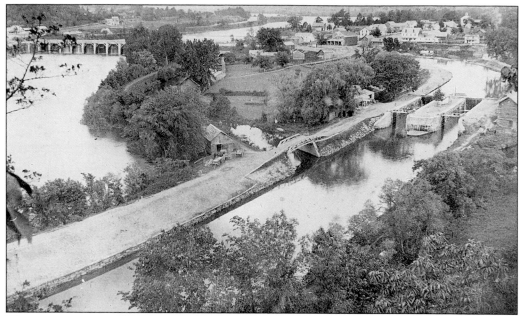

This panorama was taken from the bluff overlooking Lock No. 21 at Rexford Flats. The village of Rexford Flats can be seen at the rear on the right. The Rexford Aqueduct crosses the Mohawk River on the left.

A canal boat drawn by a three-mule team approaches a lock at Rexford Flats. The canal curves to the left and crosses the Mohawk River over the Rexford Aqueduct. A feeder canal, drawing water from the Mohawk into the canal, is at the bottom left.

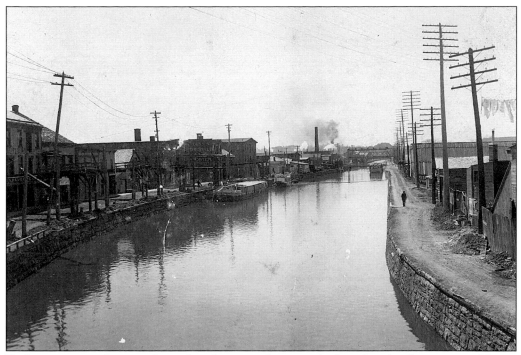

Each spring, canals were drained and crews of men with shovels, wheelbarrows, and horse carts worked to restore the prism of the canal to its original depth and the earthen walls to their stated slope. This was called "bottoming out." Here we see part of the Erie Canal in Schenectady as the channel is about half full after bottoming out has been completed.

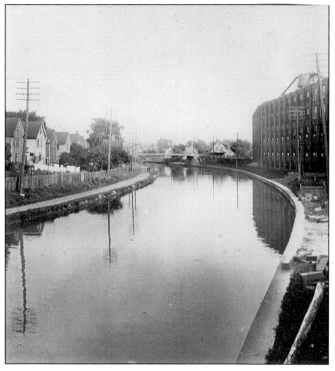

Shown is the Erie Canal, filled and ready for the spring opening and for the large volume of traffic. As you traveled the Erie Canal, it would have been common to see businesses on one side and houses on the other.

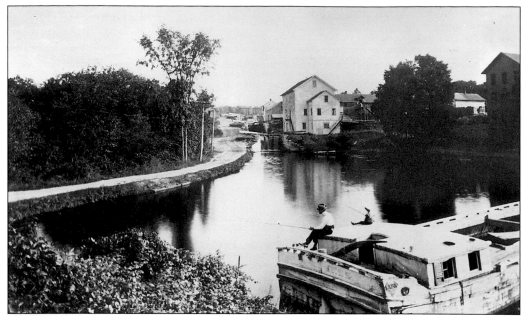

The success of the Erie Canal provided the impetus for building nine lateral canals that connected New York's northern and southern tiers to the main line of the Erie. Here, a man and boy fish in the Black River Canal at Lyons Falls. The Black River Canal ran from Lyons Falls in northern New York to the Erie Canal in Rome.

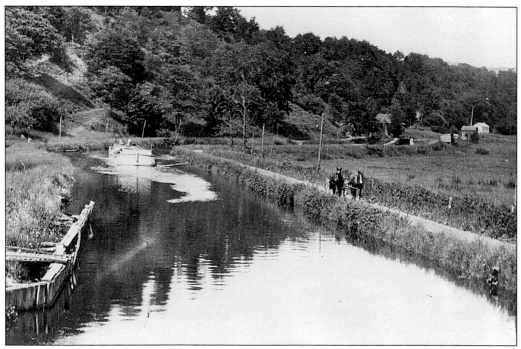

This photograph, taken on the Black River Canal, shows the distance between the mule team and the canal boat. Although never a financial success, the Black River Canal was the feeder used to maintain the water supply on the long level of the Erie Canal between Utica and Syracuse.

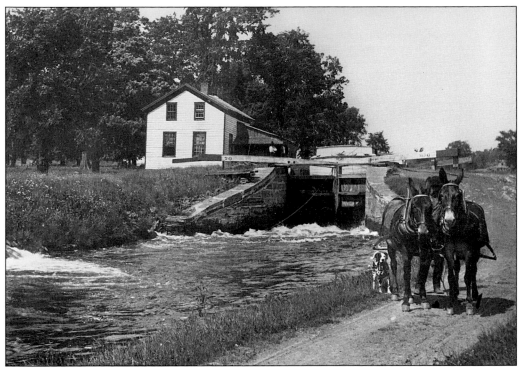

Here a boat locks through Lock No. 70 on the Black River Canal. The boat's mule team, hoggee, and faithful companion wait to resume their duties. The locktender's house is in the middle of the picture. Locktenders lived in houses at each lock and often served as the communication link for travelers. As well as being a source of the latest news, this locktender was a rich source of fresh fruits, vegetables, and flowers grown in his own garden.

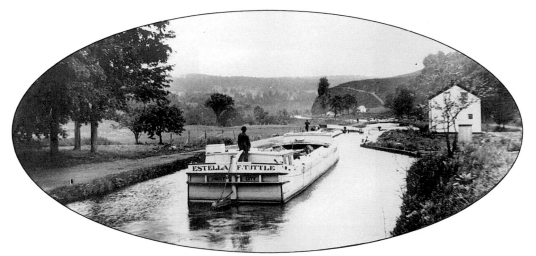

The *Estella F. Tuttle* waits to enter a lock on the Black River Canal. The locktender's house, erected to serve as an office and sleeping quarters for the locktender, is on the right. The state provided a table, three chairs, and a built-in bunk bed.

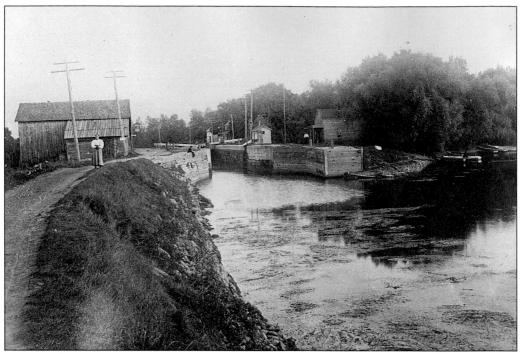

This is a view of the canal as a hoggee would have seen it, walking the towpath, approaching a lock. The earthen wall on the towpath side was part of the original design of the Erie Canal. Only locks and aqueducts were constructed of stone. The original canal had 83 locks, which were 90 feet long by 15 feet wide, 4 feet deep, with a lift of from 6 to 12 feet. All the locks were single locks except for the double locks at Lockport.

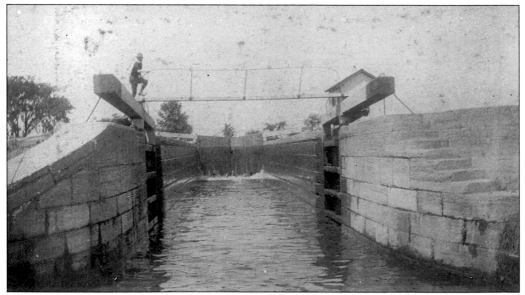

This would have been a passenger's view as a canal boat entered an open lock. There would have been conversation between the locktender, seen here on the open lock gate, and the steersman, often exchanging the latest news.

Here, a mule team tows a canal boat toward the locks at Cohoes. Extra drivers with their mule teams lived near Cohoes because of the 16 locks and the short levels between them. Those men made a living assisting canal fleets through the 16 locks.

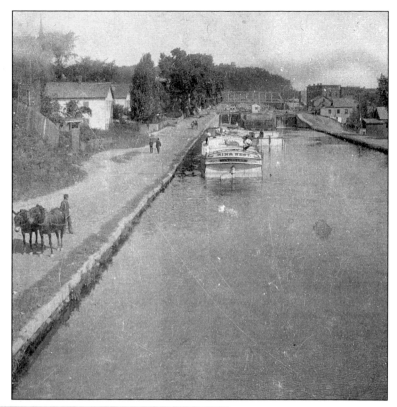

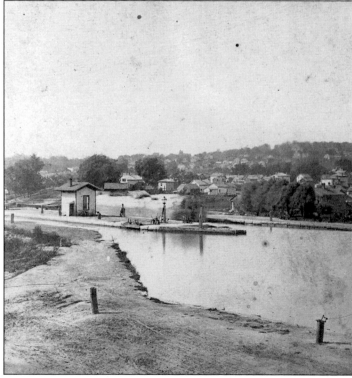

Here is a turning basin located near Lock No. 48, in Syracuse. The canal boat crews used this area to wait for their turn in the lock or to turn their boat around.

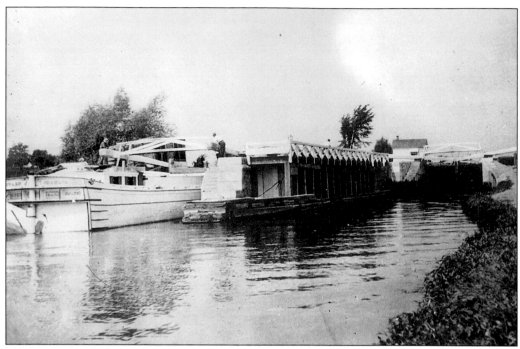

The *Howard Lodgelin* is entering a lock. The enlarged Erie Canal reduced the number of locks from 83 to 72. By 1865, a total of 57 of them were double locks. Eventually, 71 of the 72 were double locks.

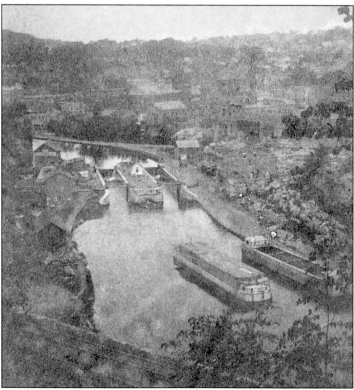

This view shows two canal boats traveling in opposite directions. The double-lock configuration, shown in this photograph, made it possible for two-way traffic to lock through at the same time, avoiding delays.

In this stereo view of the Lockport Locks, a canal boat is traveling eastward as another travels westward. When building the original canal, Nathan Roberts, the man in charge of designing the Lockport Locks, advertised for 1,000 men at $12 a month plus room and board.

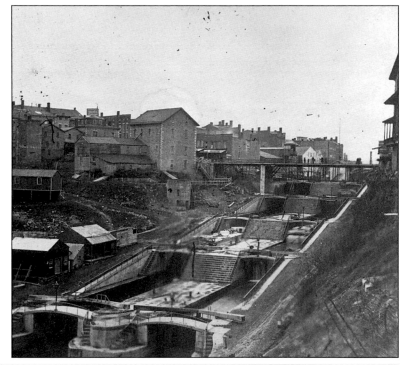

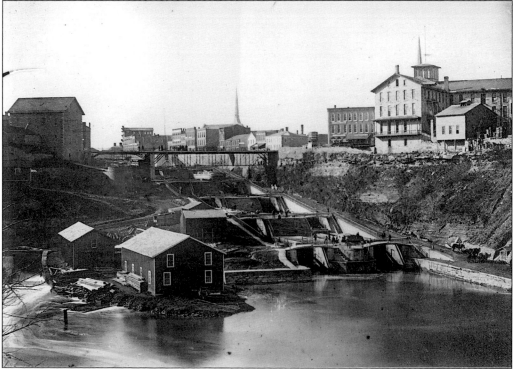

This is another view of the famous Lockport Locks. The view shows the surrounding business section of the city of Lockport. This area not only got its name from the Erie Canal construction but also had its commercial viability established by its location on the canal.

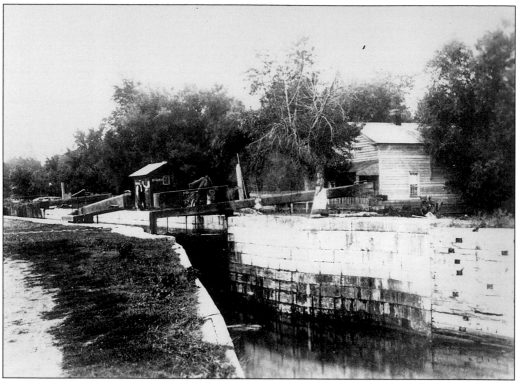

Solvay, another village created by the Erie Canal, is the location of Gere's Lock, named for the three Gere brothers who settled in the area in the early 1800s. Gere's Lock, placed in this location because of a 12-foot elevation change, was so narrow that navigating it was very difficult.

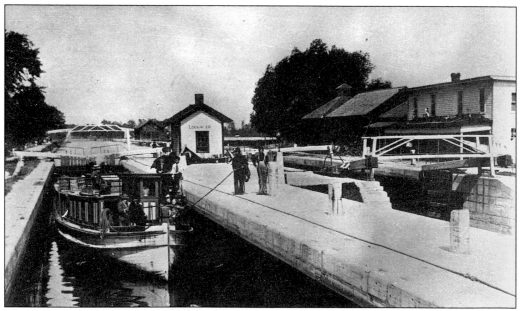

Pictured here is the upgraded version of Gere's Lock, enlarged to facilitate easier passage. Today, remnants of Gere's Lock can be found in the town of Camillus on Gerelock Road.

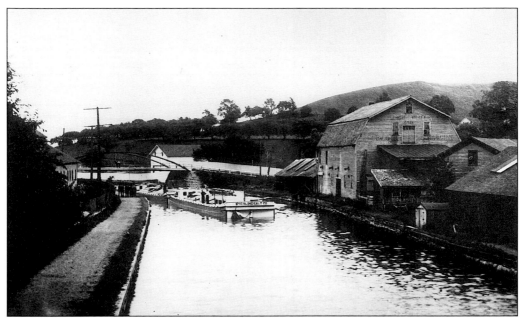

As we approach the Utica Street Bridge in Port Byron, we see the *Sterling Salt Company* "doubleheader" (two canal boats linked together) passing under the bridge. Boats were coupled together and towed by a three-span team of mules. After the canal enlargement, a doubleheader could lock through without uncoupling.

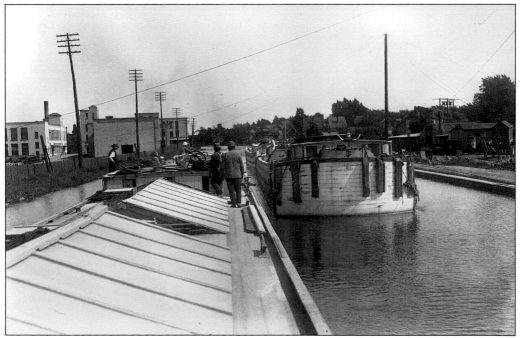

We are on board a canal boat as it passes another boat. The traffic on the canal stays in mid-channel to avoid damage to both boat and canal. The canal enlargement, which took place from 1835 to 1862, widened the channel from 40 feet to 70 feet. The sloping of the sidewalls reduced the bottom width of the enlarged canal to 42 feet.

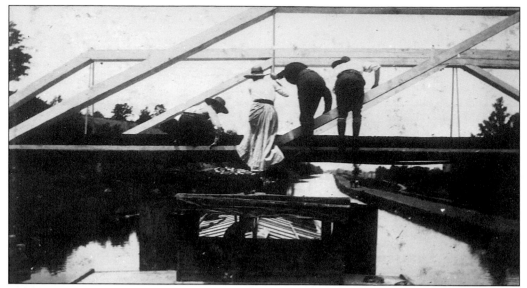

Travel on a canal boat was generally uneventful for many of its riders. Here, a game has been devised for jumping onto the bridge to add some excitement. The goal is to run across the bridge and jump back onto the boat before it passes.

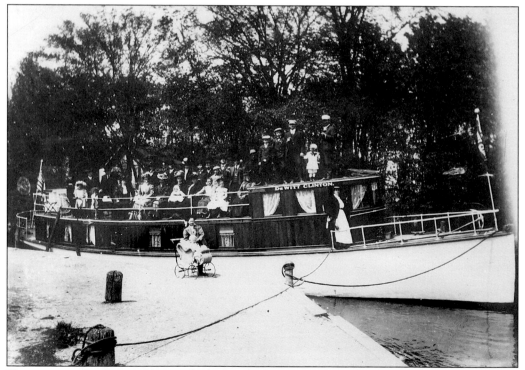

The party on the *Dewitt Clinton*, docked in Jordan, poses for a photograph before they depart. Notice the curtains in the windows. This boat offered amenities for well-to-do passengers.

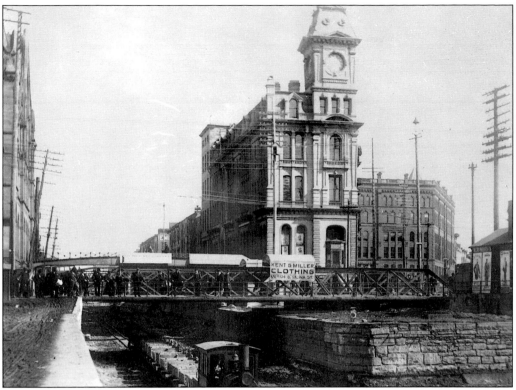

The Erie Canal bed is empty. A narrow-gauge train has been set up in the bed to repair damage. This kind of an operation would have been completed primarily during the winter months, when the canal was closed to traffic. However, there were times during the canal's operating months when such repairs became necessary and canal operations within a section were suspended.

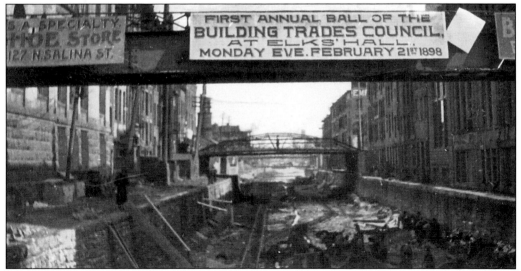

Winter was a time when the canal could be drained and necessary repairs could be made. This 1898 scene, looking east from the Salina Street Bridge in Syracuse, shows rail tracks laid in the canal to facilitate repairs.

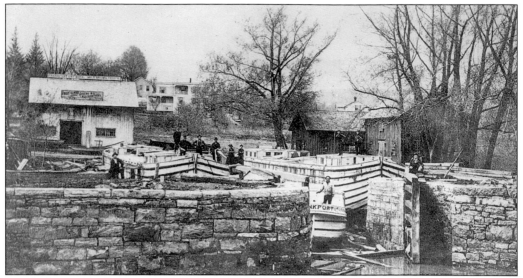

Dry docks were basins equipped with lock gates, enabling them to be completely drained so that boats could easily be supported as they were repaired. Two boats are being repaired here at Milo Brown's Frankfort Dry Dock in 1906.

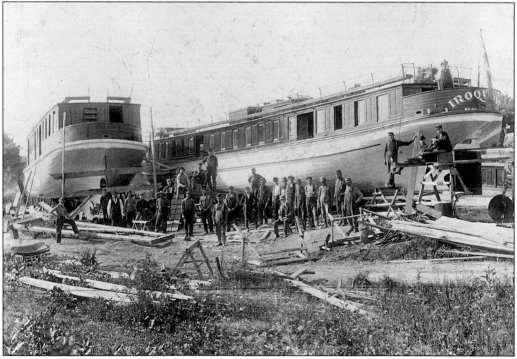

Since the life of a canal boat was only about 25 to 30 years, many workers were employed at boatyards to build the increasing numbers of boats. The workers at this boatyard in Baldwinsville, working on the *Iroquois* and *Mohawk*, take time out for a photograph during their busy day.

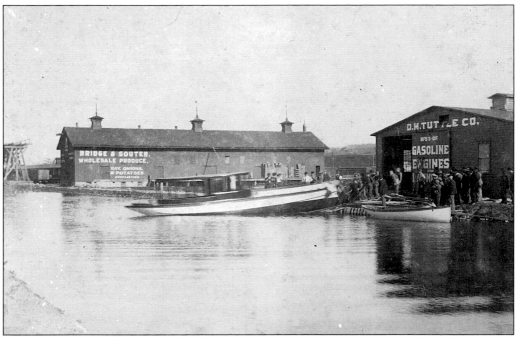

Small boat works produced only a few boats a year, as opposed to boatbuilding factories that could produce a boat in a week. It would appear from this photograph that the D.M. Tuttle Company of Canastota was one of the smaller boat works.

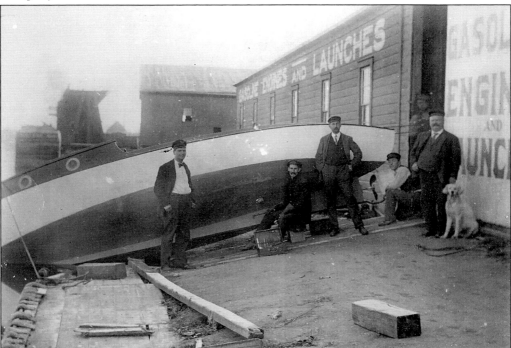

In the early days of the canal, boatbuilders had no written designs. They knew how a boat went together and were able to deliver their work on time. These men at the D.M. Tuttle Company pose alongside a more modern launch.

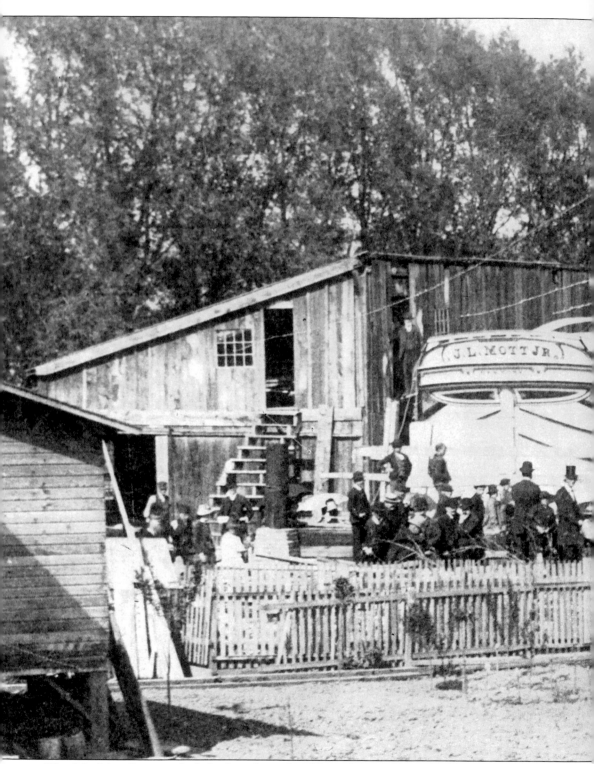

The *J.L. Mott Jr.* is readied for launch at this Ithaca boatyard. Boatbuilders had their own designs for construction of each type of boat. A busy yard could have up to six boats under

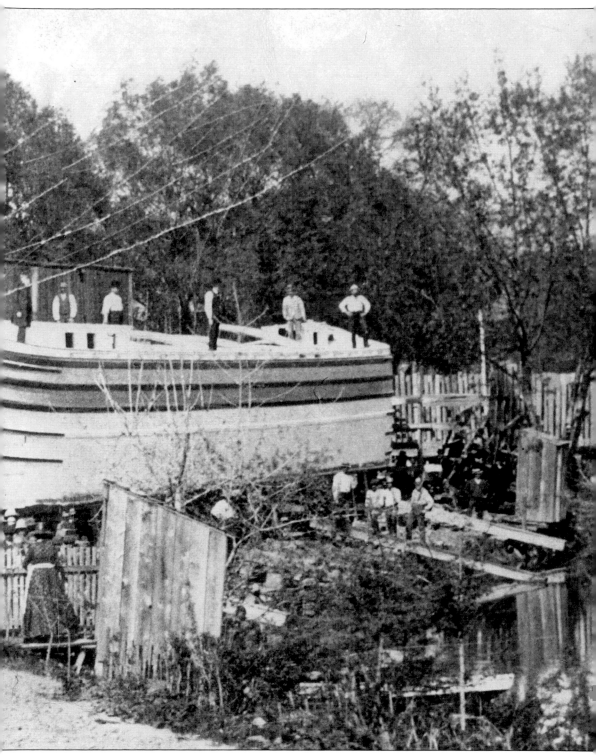

construction at one time.

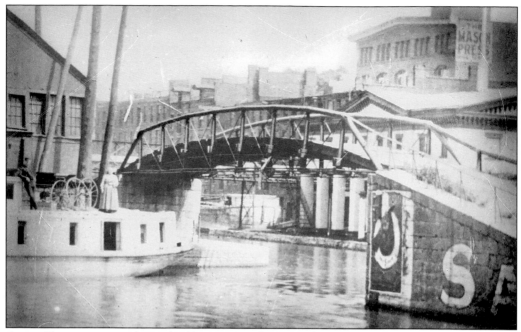

A canal boat is coming down the Oswego Canal, approaching the junction with the Erie Canal. The steersman would be watching carefully for other canal traffic as the boat passed under the change bridge on its way to the Syracuse Weighlock.

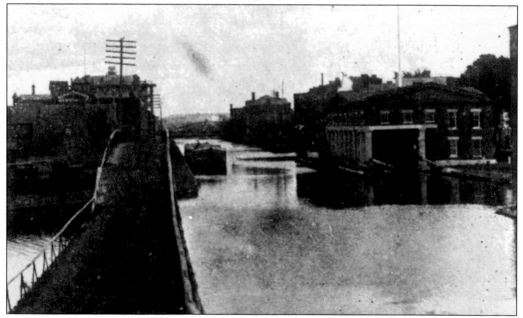

A hoggee walking the towpath over this change bridge with his team would be waiting for his canal boat to be weighed here at the Syracuse Weighlock. Boats entered the weighlock and then the lock gates would close and the sluice gates would open, emptying the water from the lock. The boat would come to rest on the wooden cradle in the chamber, and the weighmaster would collect a toll based on the weight of the cargo and its destination. Water would then fill the lock, and the boat would resume its journey.

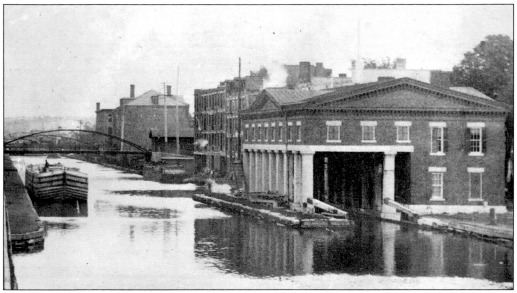

This closer view of the Syracuse Weighlock, built in 1850, shows the lock gates on the western end of the building. This weighlock, actually Syracuse's third and the only remaining canal-era weighlock, today is the home of the Erie Canal Museum.

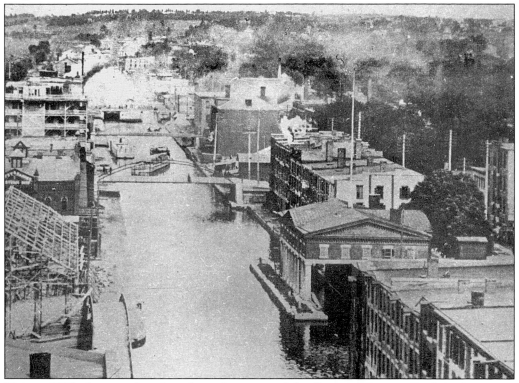

This *c.* 1895 photograph, taken from the tower of the Syracuse Savings Bank looking east, shows the Syracuse Weighlock to the right and the construction of a steam plant to the left. Today, what was once the Erie Canal is Erie Boulevard, carrying traffic east and west through the city.

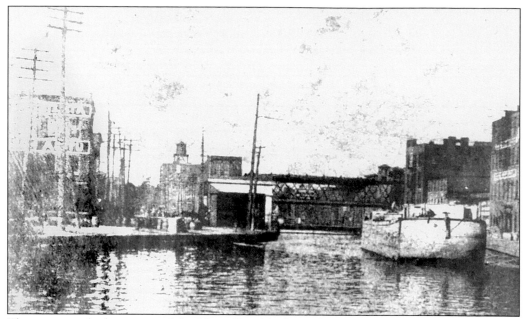

This is a view looking west of the Utica Weighlock on the Erie Canal. Even before the 1825 official opening of the canal, $28,000 in tolls was collected on the Erie's first section, which included Utica. By 1824, some 10,000 boats paid $300,000 in tolls on the open sections.

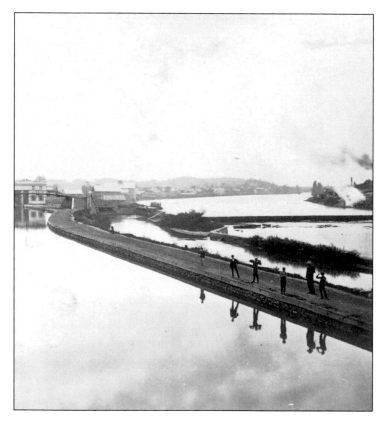

This photograph, taken in the Rochester area, shows several men on the towpath heading toward a weighlock building on the left.

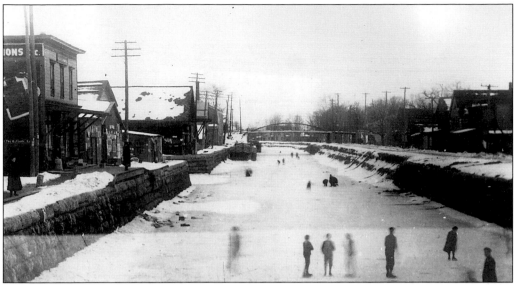

The canal was closed and drained from the first winter freeze until the first spring thaw. In some areas, enough water was left in the canal to enable residents to enjoy ice-skating. This photograph of ice-skating in Canastota illustrates the canal's year-round use by all its nearby communities, large and small.

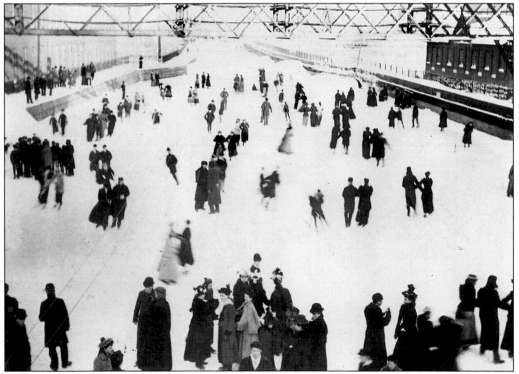

Winter's cold weather allowed canal-side citizens to entertain themselves on the canal. The almost completely drained iced-over canal was used as an ice-skating rink in canal communities. Near the Genesee River Aqueduct in Rochester, a large group of people is shown skating on the canal.

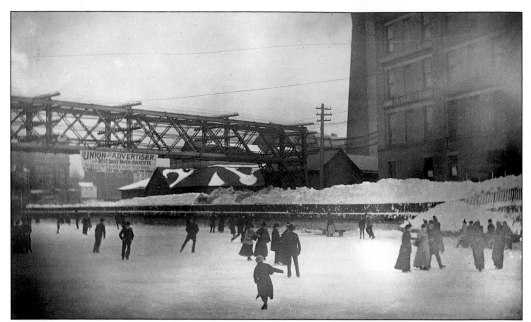

Again, near the Genesee River Aqueduct in Rochester, this image shows the Union Advertiser sign probably used as a landmark by the skaters. There are stories of people who would skate for several hours along the canal and cover distances of many miles.

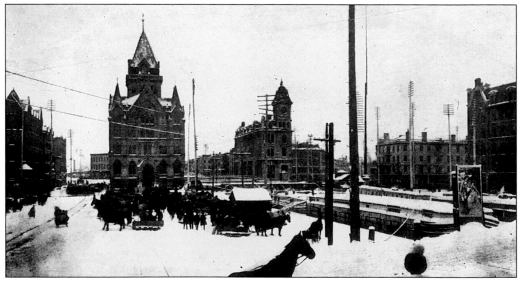

As these snow-covered boats indicate, winter required canal boats to tie up for the duration. In this photograph of Clinton Square in Syracuse, horse-drawn sleighs congregate along the north side of the canal.

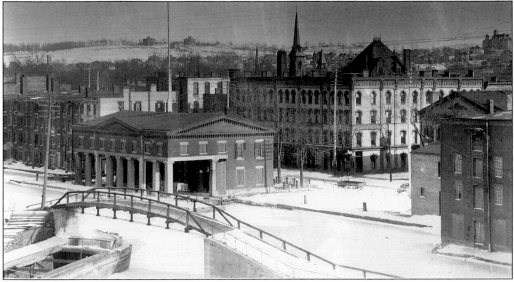

The canal froze over in winter, stopping all traffic. This view is of the junction of the Erie and Oswego Canals at the Syracuse Weighlock in the winter of 1888–1889. Syracuse University's Hall of Languages is the twin-towered building on the hill to the right.

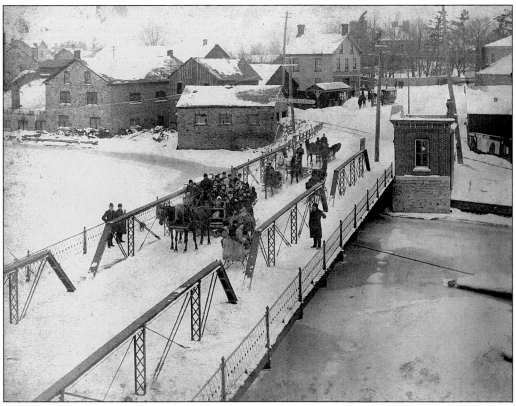

The canal also offered many bridges over which to travel in a horse and sleigh. A children's sleigh ride party is shown crossing the bridge over the frozen Erie Canal in the early 1890s.

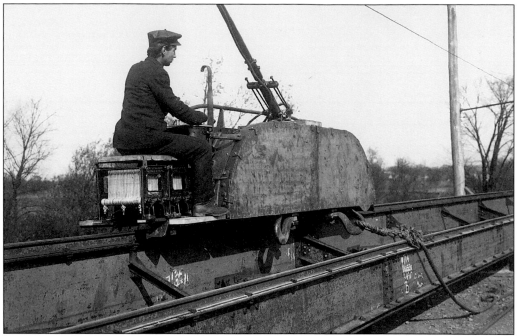

The wave of new technologies that crossed the United States did not miss the Erie Canal. International Towing and Power Company devised an experimental electric mule to be used to tow boats on the canal. A mile-long rail track was built along the towpath opposite the Edison General Electric Company's factory in Schenectady.

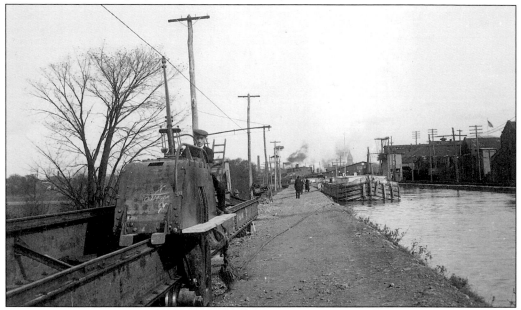

Power for the electric mules was drawn from wires on trolley poles along the side of the canal. In an experimental demonstration, the electric mule drew up to four 240-ton canal boats over the one-mile course at five miles per hour. Results of the experiment were considered successful both as to speed and freedom from wash on the banks of the canal. Nevertheless, the state declined to issue a permit and electric mules faded into history.

Three

BOATS, BRIDGES, AND AQUEDUCTS

When the original Erie Canal was built, from 1817 to 1825, there were no trained engineers in the United States. Using rudimentary tools and learning as they went, the canal builders learned to overcome what must have seemed like insurmountable obstacles. How do you bring the canal across rivers and up the 500-plus feet of elevation change between Albany and Buffalo? Many farmers had their land split by the canal, and bridges had to be built to allow these farmers to continue their work. Most of the nearly 300 bridges built on the original canal were these so-called "occupational bridges."

A look at the Erie Canal would be incomplete without attention to the boats that floated along the canal. Through the photographs in this chapter, the reader is shown the canal boat from its construction to its varied uses, its livability, and its technological change from animal power to steam.

The photographs of the canal structures, bridges, locks, and aqueducts exemplify the ability of human beings, with only rudimentary tools and little knowledge of civil engineering, to create structures built of stone, wood, and metal that would take the canal over natural bodies of water and other obstacles. The structures these people built were not only useful but also aesthetically pleasing. It is amazing to take these photographs and compare them to the structures as they survive today.

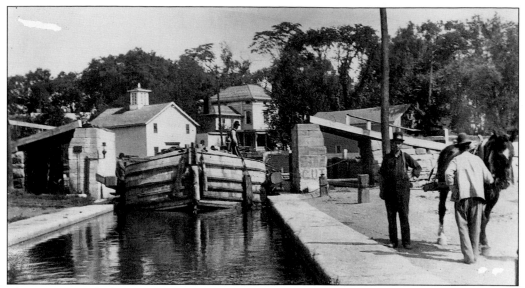

This is a view of a boat entering a lock on the Champlain Canal, c. 1880s. The boat entered the lock chamber through an open gate (mitre gate) and the gate closed. Water was allowed in from upstream through the sluice gate to raise the boat or released through the downstream gate to lower the boat.

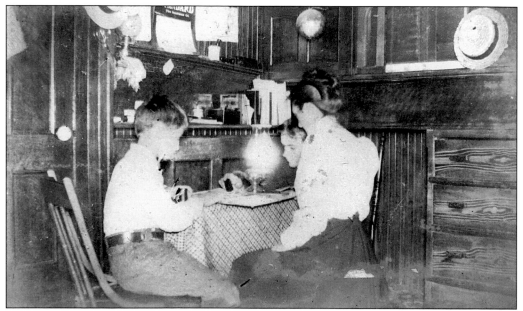

Canal families lived and worked on board their boats. Living quarters were in the rear of the boat. Children attended school when the canal was closed for the winter. Many boats would lay over in New York City for the winter, and boatmen's children would often attend the winter term in the city.

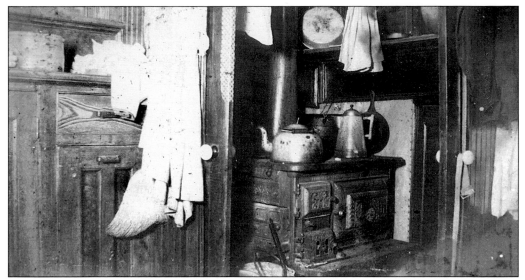

This photograph shows the interior of the *Paddy McLoughlin*, with its kitchen stove and the surrounding cabinetry. A description of a kitchen aboard a canal boat given by a newspaper reporter of the day tells that the galley is big enough to hold the stove and little else.

This photograph shows a close-up view of the *Paddy McLoughlin's* cupboards and drawers. The newspaper article referenced above goes on to say that there is a closet for wearing apparel and, leading off from the closet, the bunk, which is built under the desk. When the captain goes to bed, he must sidle into his berth, as though he were a box being placed on the shelf of a dry goods store.

The side of the canal opposite the towpath was referred to as the berm. This view of the Erie Canal clearly shows both the towpath side of the canal, reinforced by stones, and the berm

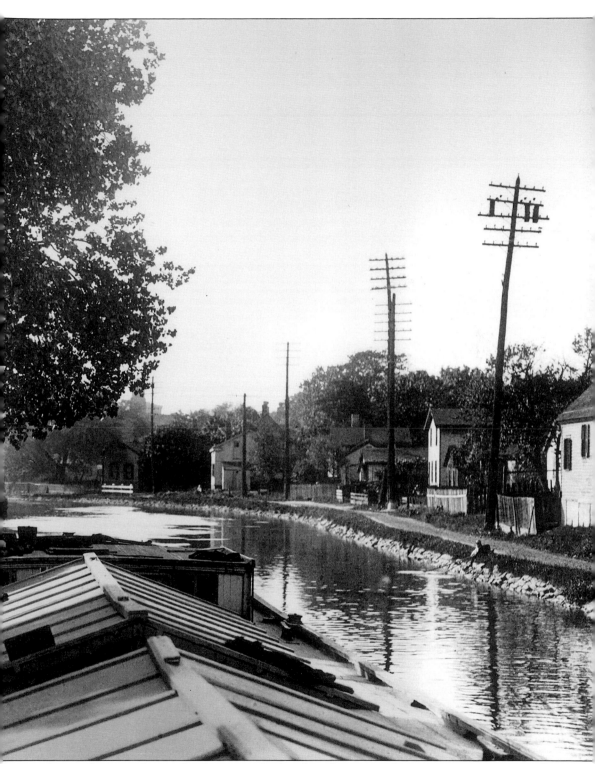

side, usually an earthen embankment cut higher than the surrounding terrain to prevent runoff into the canal.

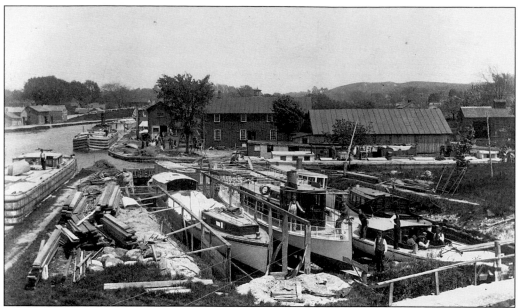

Dry docks were located along the Erie Canal to facilitate boat repair and construction. This is the O.B. & H.F. Tanner Dry Dock at Port Byron, west of Syracuse. Dry docks were simple structures placed alongside the towpath or the adjoining berm bank—usually nothing more than a lock large enough to hold one or two boats.

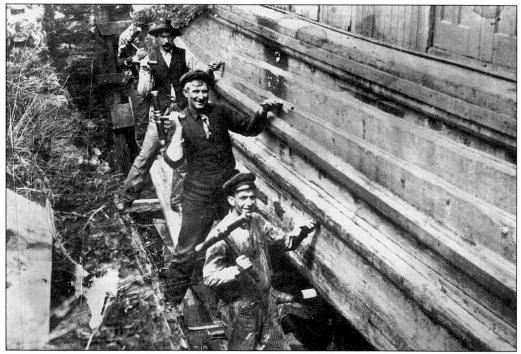

At Tanner's Dry Dock, these caulkers (often called corkers) are using chisel-like caulking irons and large-headed wooden mallets to drive tarred hemp rope fibers (oakum) into the seams between the boards to make the boat watertight. Up to four layers were necessary for a good seal.

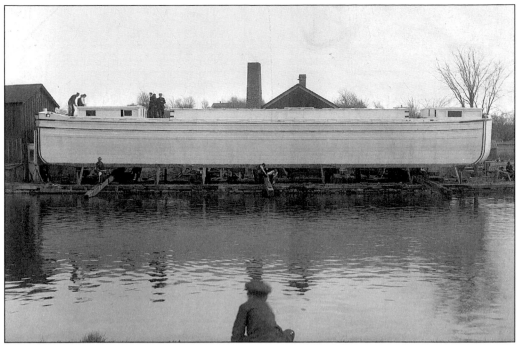

Here we watch the launch of a new canal boat at the Port Byron dry dock in the early 1900s. Boats slid off their pedestals and down slanted greased logs into the water. Canal boats were almost completely finished in the yard, with little work to be done after launch.

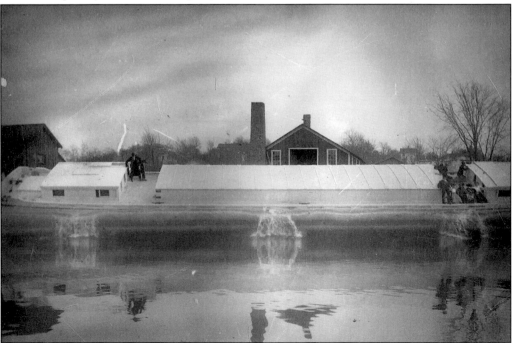

Canal boats were launched sideways because the boats were usually longer than the canal was wide. An amusing thing to do was to ride the boat as it was launched down the ways into the canal. The ride was short, but the splash must have been impressive.

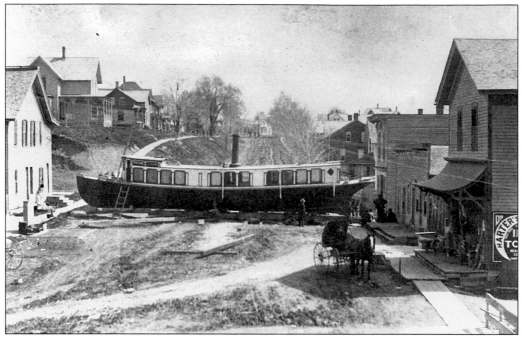

What would you have thought as you came across this sight traveling down this street in Boonville? It appears this steamer is being readied for launch into the Black River Canal, out of the picture to the right.

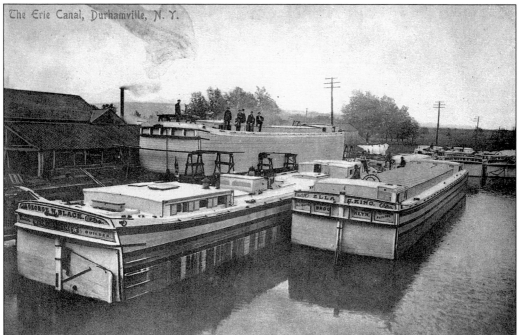

Boat sizes had to comply with official rules and regulations as well as the dimensions of the canal locks. It has been said that any canal boatman could easily identify the builder and boatyard of every boat he saw, since every builder used his own subtle characteristics. These boats are docked at Durhamville.

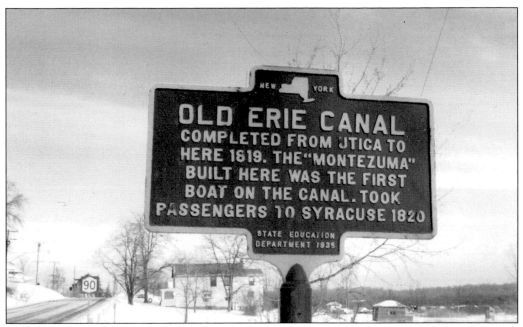

The *Montezuma* named on this sign was captained by a Captain Brown and was 75 feet in length with a 12-foot beam and drew 20 inches of water. According to Brown, the boat would comfortably accommodate 10 to 12 passengers, though it often carried twice that number. Passage on the boat in 1820 from Utica to Montezuma, 94 miles west of Utica, was $4.

This *c.* 1880 photograph shows Sautelle's circus boats tied up in Clinton Square for the winter. Harlow B. Andrews, owner of an early Syracuse chain of groceries, bought one of Sautelle's circus boats, the *Kitty of Utica*, and paid for its transformation into the Rescue Mission's *Good News*. After only one season, the *Good News*, while tied up next to C.H. Baker's Lumber Yard on the Oswego Canal in Syracuse, was destroyed by a fire that ravaged the yard in 1894.

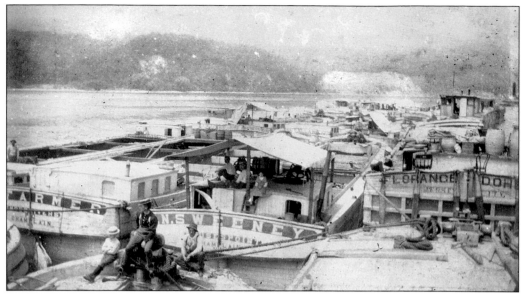

A scow was a short steerable workboat that was square at the bow and stern. Scows saw service hauling sand, gravel, construction stone, coal, and other materials. These were the cheapest boats afloat—literally a hole in the water lined with wood.

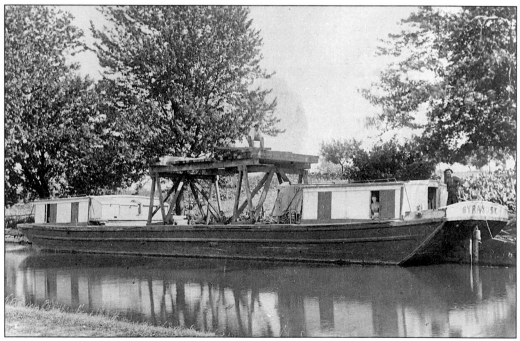

The *Syracuse,* a work scow, is shown tied to the side of the canal. One to three repair scows worked on each of the 11 repair sections of the Erie Canal. In the event of a break in the canal, the scows hurried to the spot to immediately begin repairs. Their ability to move quickly earned these boats the nickname of "hurry-up" boats.

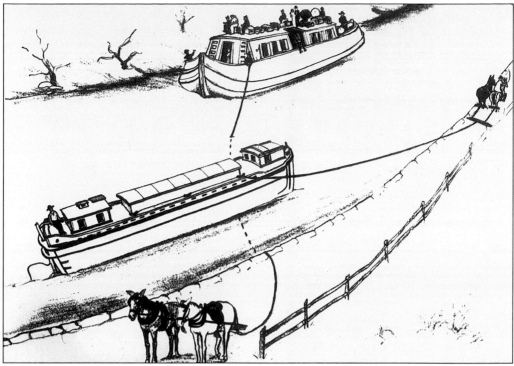

As the drawing illustrates, the towpath was only on one side of the canal. Boats headed in different directions approached each other with care. The outside boat, shown in the background, pulled to the non-towpath side of the canal, stopped its team, and dropped its line, as indicated by the dotted line. The inside boat passed over the other boat's line, and then both boats continued on their way. Up-bound boats kept to the towpath side, and loaded boats kept to the heel path side. Loaded boats dropped their towline so that light boats crossed the line of heavy boats.

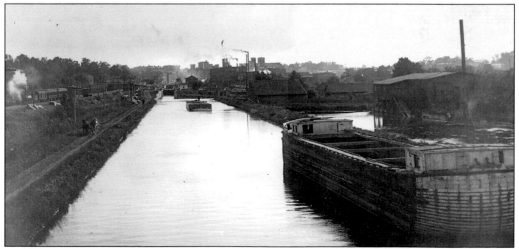

Animal power propelled the Erie Canal into the annals of American history. This technology was used until the opening of the New York State Barge Canal in the 1920s. This photograph shows the operation of the Erie Canal with the new technology of the steam-powered railroad, snaking right alongside.

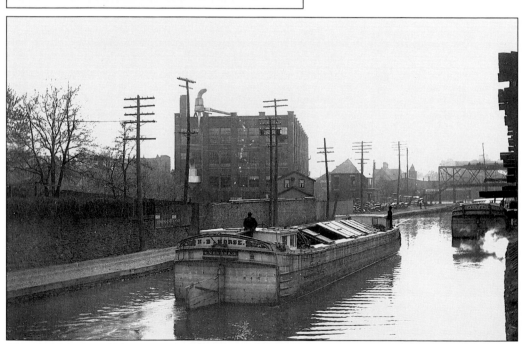

OPPOSITION TO THE RAIL ROAD.

Red Bird Line

FOR ROCHESTER,
SYRACUSE AND SCHENECTADY.
THE NEW AND SPLENDID

PACKET BOAT

NIAGARA

CAPT. D. H. BROMLEY,
Leaves Buffalo for Lockport and Rochester,

THIS EVENING,
AT 7 O'CLOCK,

And arrive at Rochester in time to take the Packet or Rail Road
to Syracuse, making the passage to Syracuse in Thirty Hours.

N. B. THIS NEW PACKET IS

100 Feet Long

Fitted up expressly for pleasure travel, with

LADIES' AND GENTLEMEN'S SALOONS,
and ventilators in the Deck.

PASSAGE,

TO ROCHESTER,	- - - - - -	**$1,50**
PASSAGE TO ROCHESTER, including Board,	- -	2,00
" " SYRACUSE,	" "	- - 4,50
" " UTICA,	" "	- - 6,00
" " SCHENECTADY,	" "	- - 7,50
WITHOUT BOARD,	- - - - -	**$5,50**

FOR PASSAGE
Apply to the CAPTAIN on Board, or at the PACKET DOCK
OFFICE, Commercial Street Dock.

H. STILWELL & CO.—Proprietors.

Buffalo, 1847. **L. E. HARRIS,**—Agent

Steam Press of Jewett, Thomas & Co., Com. Adv. Office.

This 1847 broadside advertises the pleasures of packet boat travel on the Erie Canal. This poster shows that the canal was already feeling competition from the railroads.

The *N.B. Morse* of Verona is shown passing the *Carey Bros.* boat docked in Rochester. From its inception, shipping on the Erie Canal increased year by year, as did the populations of the cities through which the canal passed. Between 1835 and 1850, Rochester's population more than doubled.

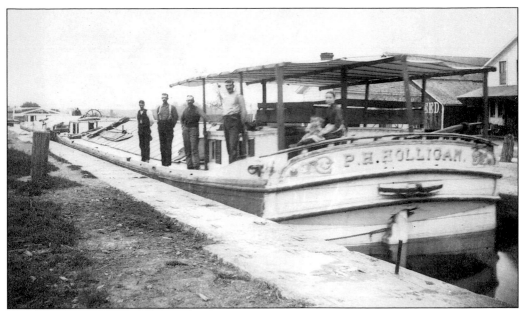

Scows varied considerably in size and shape, limited only by the size of the locks and the imagination and ability of the builders. Most scows were built to the specific requirements of their owners, who, in most cases were the builders themselves. Some scows were completely open, or un-decked. Frequently a crude cabin or a canvas over poles (usually toward the stern) offered shelter.

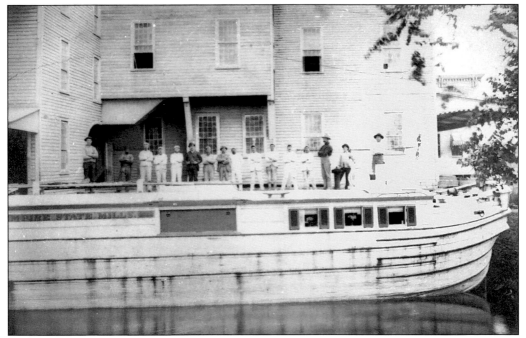

Bullheads were well-built boats with cabinlike covers running the full length to protect the cargo. These boats were used for carrying flour, grain, and other products that required absolutely dry cargo holds. This bullhead, *Empire State Mills*, is moored at the Amos Flour Mill in Syracuse.

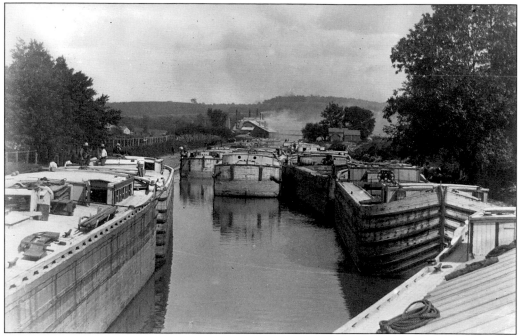

This photograph shows the Erie Canal equivalent of a modern traffic jam. Although most traffic backups occurred near locks, this one was the result of low water, perhaps caused by a break in the canal wall.

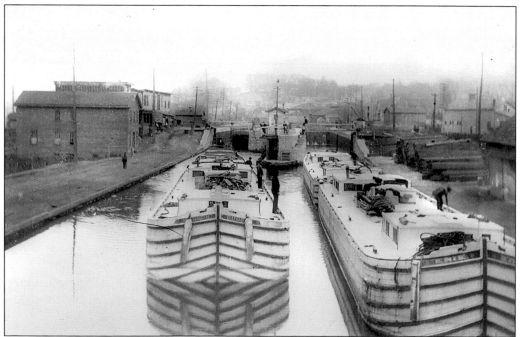

This picture shows the double locks at Beech Street in Syracuse. Making the locks double was part of the 1835 enlargement of the canal. The state legislature approved enlarging the width from 40 feet to 70 feet and the depth from 4 feet to 7 feet. The lock size was increased to 110 feet by 18 feet.

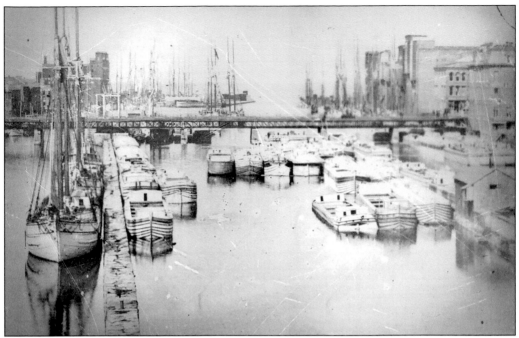

The presence of masted ships alongside canal boats indicates this photograph was taken in Buffalo at the western end of the Erie Canal. The *Northern Traveler and Northern Tour*, a fourth-edition pocket guide from 1830, described Buffalo's harbor as being singularly fitted by nature for the junction of two kinds of navigation.

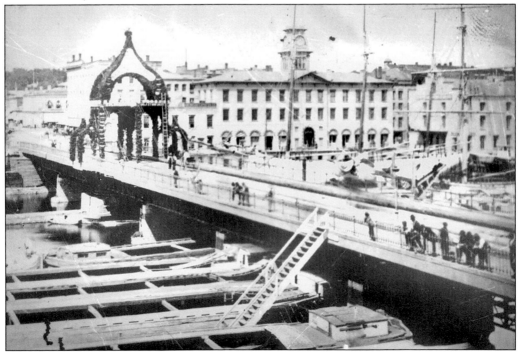

Onlookers seem to be more interested in the lineup of canal boats on this side of the bridge than in the masted ship on the other side. Again, the scene seems to be in Buffalo.

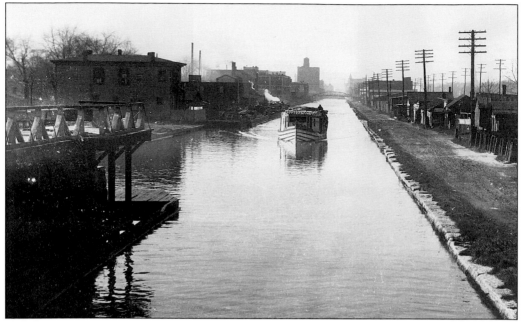

Here you are looking at a steamboat traveling east on the canal in Syracuse. The Crouse Avenue Bridge can be seen in the distance. This photograph was taken in 1917, just a few years before this section of the canal was filled in.

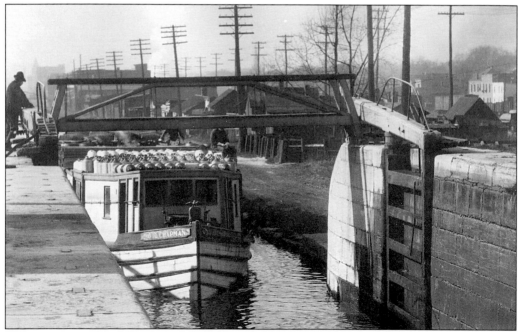

The steamboat *David Chapman* is locking through at an unknown location. The single locks on the original Erie Canal cost about $10,000 each and required frequent repair and extensive rebuilding within 15 to 20 years.

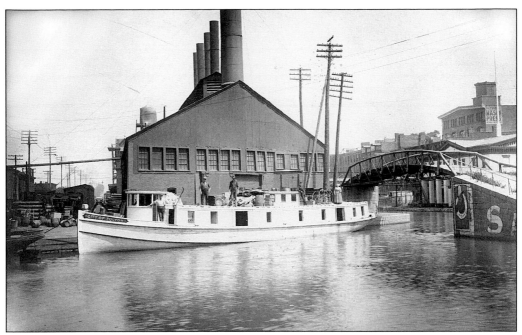

The *City of Fulton* is stopped in front of the Syracuse Heat and Power Company steam station *c.* 1900. Notice the change bridge, used to carry the Erie Canal towpath across the Oswego Canal. Looking across the Erie Canal from under the bridge, you can see the pillars of the Syracuse Weighlock Building.

This view of a steam-powered canal boat shows off the improvement of design and the addition of colorful canvas side panels and roof. These improvements offered passengers a more comfortable ride, especially on a rainy day. Notice the horse and buggy crossing the bridge behind the boat.

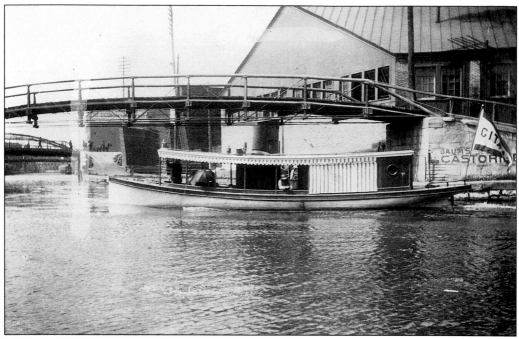

This steamer is identified as a Syracuse river taxi of 1890. The surroundings indicate the many bridges to be found in an urban area.

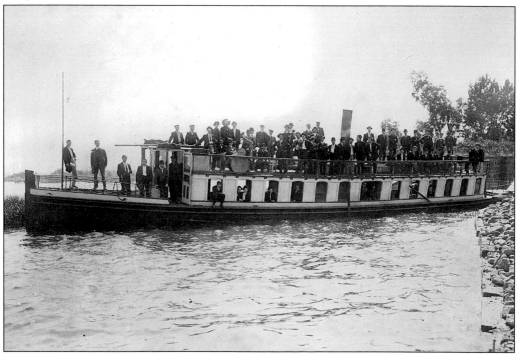

This steam packet boat carries passengers in Medina. Packets were long, narrow passenger boats that hauled people over long distances in relative comfort, particularly compared to stagecoaches. In 1843, there were 40 packet boats traveling the Erie Canal. The number of packet boats declined as the railroads gained popularity.

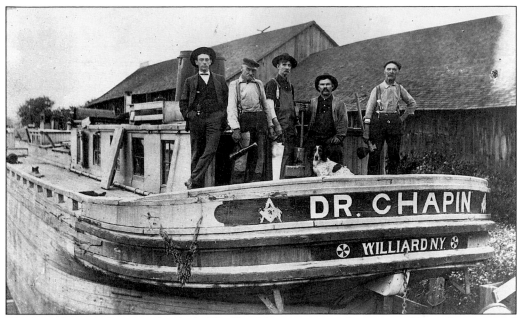

The *Dr. Chapin* is shown in dry dock. The *Dr. Chapin* is a typical steam canal boat that operated on the Erie Canal right into the 20th century. That this vessel is a steamer is shown quite clearly. Note that the stern is rounded rather than square or box-shaped, as a regular canal boat would be. It also has a raised taffrail (the rail around the stern end of the boat) to prevent fouling the tiller. The man with the bow tie is most likely the captain.

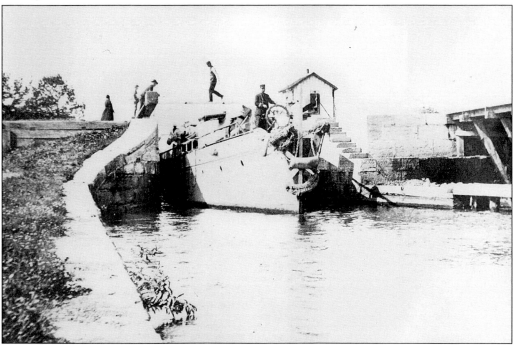

This photograph shows a canal boat coming east out of Lock No. 19 at Vischers Ferry. The steering wheel is at the bow of the boat. This method of steering came with steam power. Before the advent of steam, the steering was done at the stern with tiller and rudder.

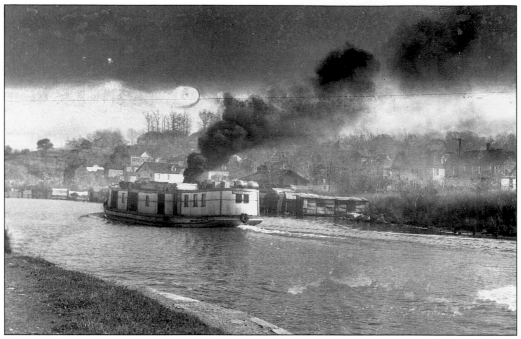

The *David Chapman* is going east at Lodi Locks in Syracuse. A captain on the canal said that running a single boat and earning $500 or $600 a season is a good season. Often captains ran doubleheaders, two boats together, which would cost the same as a single but earn double.

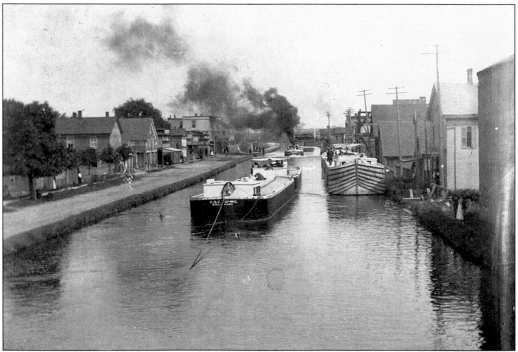

A fleet of new canal barges passes through Canastota en route from Cleveland, Ohio, to New York City on August 22, 1895. An older canal boat can be seen moored along the south side of the canal.

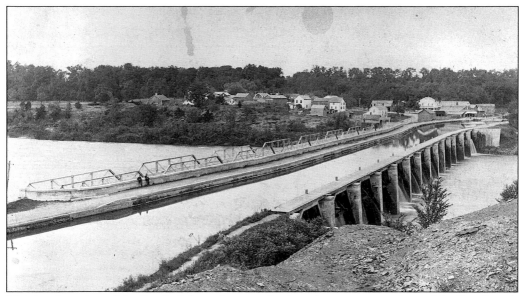

This is a fine view of the Rexford Aqueduct, not far from the eastern terminus of the Erie Canal. This aqueduct carried the Erie Canal and towpath across the Mohawk River. The town of Rexford is in the background. This aqueduct was 610 feet long, fifth longest on the canal, with 14 spans. Today, the abutments of the aqueduct are well preserved in a parklike atmosphere near the Route 146 Bridge.

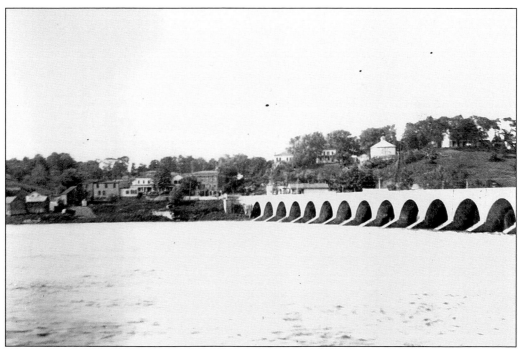

Thirty-two aqueducts were constructed during the canal enlargement begun in 1835. This aqueduct at Crescent was the longest on the canal, at 1,137 feet with 26 spans. Today, only a few stone remnants remain.

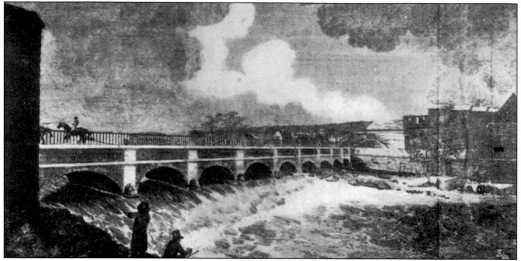

The aqueduct over the Genesee River in Rochester, the third largest on the canal, is 810 feet long with 10 arches. It stands today as originally constructed in 1842 and easily supports the heavy weight of the Broad Street Bridge in downtown Rochester.

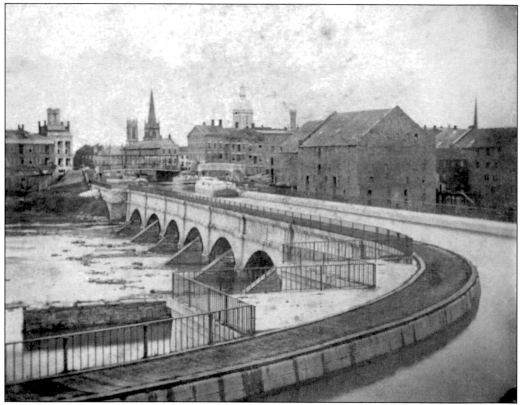

This stereoscope photograph shows canal boats crossing the aqueduct over the Genesee River in Rochester. An aqueduct was a structure made of stone that was designed to carry the canal and the towpath over a stream or river.

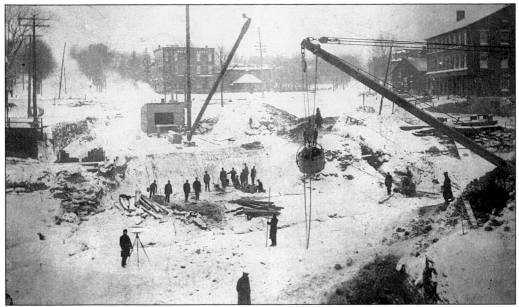

Wintertime was an excellent time for construction and improvement on the Erie Canal because sections could be drained for the season. Here, workers are constructing a lift bridge over the canal at West Genesee Street in Syracuse during January 1897.

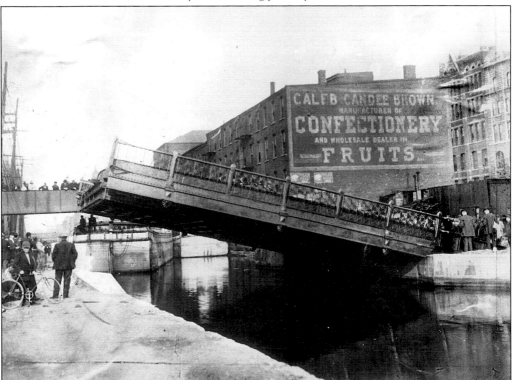

There were many types of movable bridges on the canal. Pictured here is a bascule bridge, so named from the French word for seesaw. This raised bridge has several pedestrians in Syracuse waiting to cross.

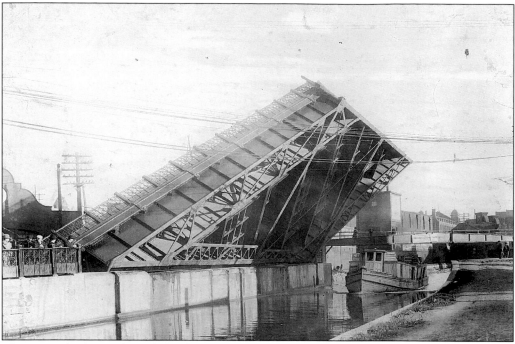

This swing bridge, or bascule bridge, was located over the Oswego Canal in Syracuse. It has been swung aside to allow the canal traffic to pass.

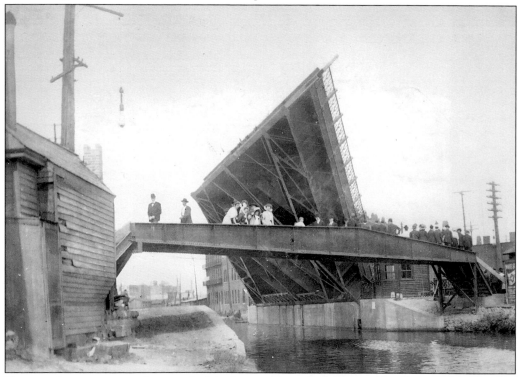

Here, we have a mystery for you. Is this the same bascule bridge on the Oswego Canal as the one above, viewed from the other side?

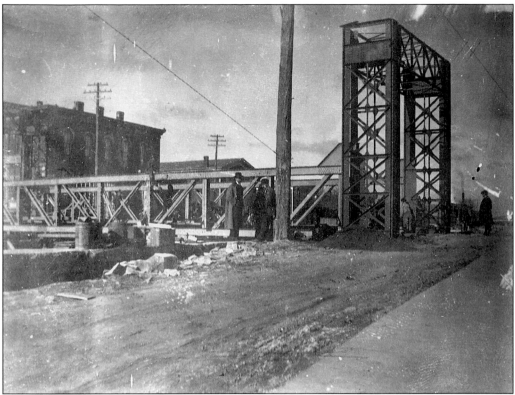

Pictured here is the Peterboro Street Lift Bridge under construction in Canastota. The Erie Canal ran through the middle of this rural village in central New York and was directly responsible for the growth of its economy.

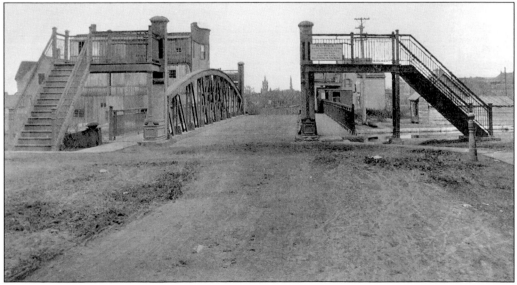

A lift bridge was capable of being raised to allow boats to pass. This view looks across the Emerson Street Bridge in Rochester. The stairs allowed pedestrians to cross the canal while the bridge was in the lift position.

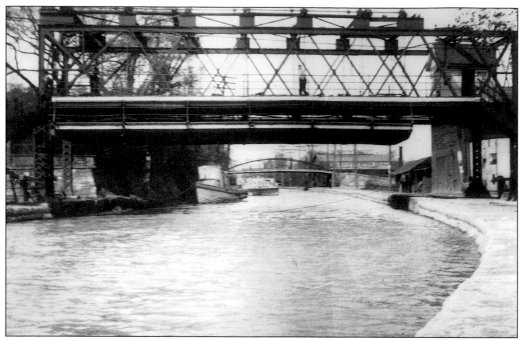

This photograph, taken on the canal in Waterford, shows two bridges. In the foreground is the lift bridge in the lift position, allowing passing canal traffic to continue as a townsman crosses above. In the background is a fixed bridge.

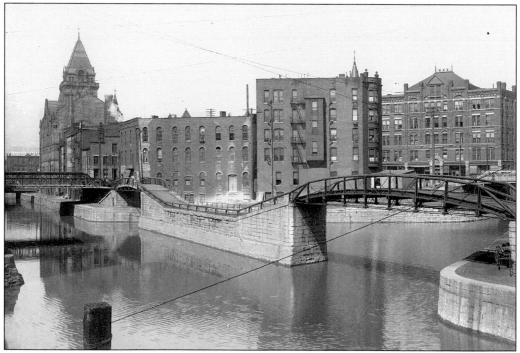

This is the change bridge at the junction of the Erie and Oswego Canals in Syracuse. A change bridge allowed a team of mules or horses to cross over and descend to the other side of the canal without fouling or detaching the towline.

This bridge crosses the Erie Canal in downtown Utica. The first section of the canal was built from Rome to Utica and, as early as 1825, about 1,000 passengers passed through Utica daily. Utica's population grew almost 200 percent during the 1820s.

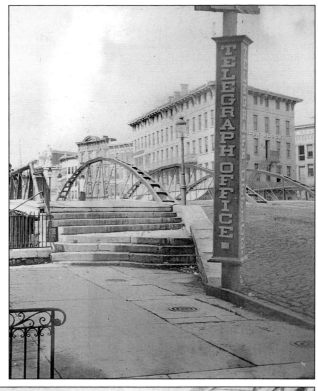

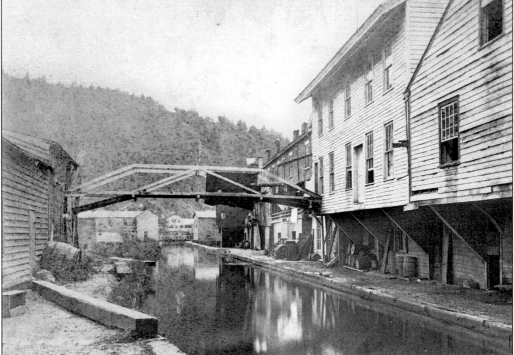

This stereograph of Little Falls shows just how close businesses were built to the canal. Bridges allowed pedestrians to cross while traffic on the canal continued on its way.

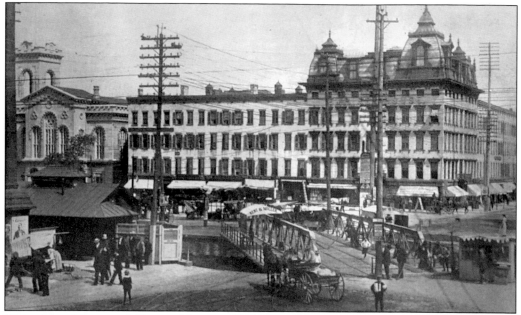

This view of Syracuse's Empire House with the canal and its swing bridge in the foreground would easily lead one to concur with the members of the New York Artists' Fund Society who, upon entering Syracuse at dusk, compared Clinton Square to a Venetian scene.

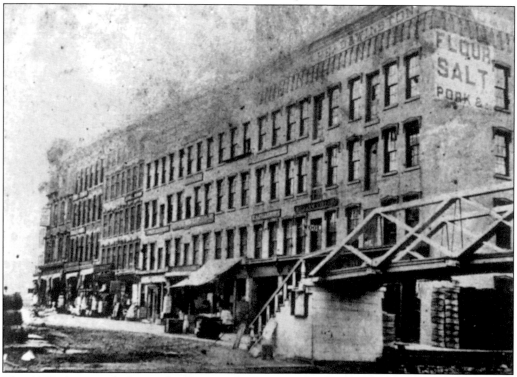

This 1870 photograph shows a building on the Erie Canal at the Hotel Street Bridge in Utica. At the time, Head & Winston Wholesalers, dealers in grain and provisions, occupied the building. The building was eventually razed, and the Franklin Building was erected on the site.

Four

BUSINESS AND INDUSTRY

The construction of the original Erie Canal created employment for many: surveyors, who staked out the 60-foot-wide path that would include the 40-foot-wide channel, the 10-foot-wide berm, and the 10-foot-wide towpath; clearers, who chopped through the wilderness; canal diggers, who dug the channel four feet deep, often through difficult terrain; farmers across whose land the canal cut through; and others who lived along the route. The canal economy grew to a work force of over 50,000 people in the peak canal years, with about half employed on the boats and the rest working on locks, as maintenance crews, as towpath walkers, and as canal-side shopkeepers.

Land along the old Erie Canal was dotted with businesses and industries that counted on the canal to transport raw materials into and finished goods out of the area. Through the following photographs, you will journey past some of the many types of establishments that the Erie Canal fostered. You will notice the buildings' locations so close to the canal and nearby docks, wagons, storage areas, signage, and roads—all of which will illustrate the strong connection in the 19th century between the canal and the economy.

Focus your economic eye on this view of the business and commerce of the Erie Canal.

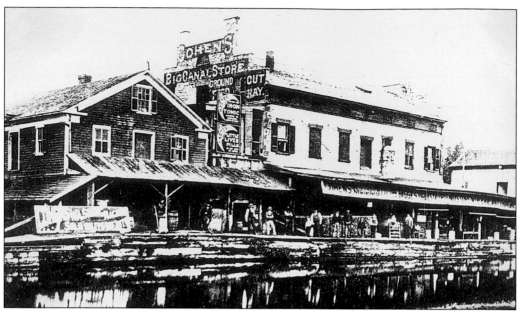

Cohen's Big Canal Store, in Sprakers Basin, was advertised as the "biggest and best all around store on the canal with anything and everything." Boat captains and their families and crews would stop at stores along the canal and charge the goods purchased. On the return trip, they would stop to pay their debt and possibly buy more. Stores like Cohen's would open in the middle of the night to take care of passing boaters' needs.

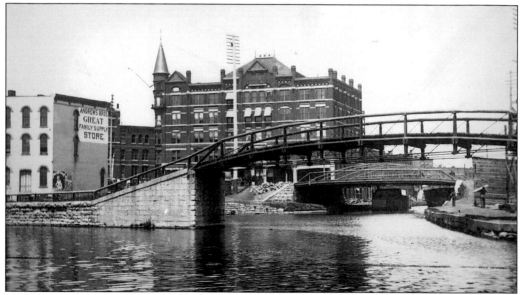

This boat view of an Erie Canal change bridge and the Oswego Canal also shows Andrews Brothers Great Family Supply Store on the left. Business along the canal had been steady from Buffalo to Albany when the canal's boat traffic was greatest. There were more stores on the canal than there were miles. Stores were well stocked with both groceries and dry goods. When the boats began doubling, often running groups of four or more, one of the boats would carry supplies. Land-based stores then had to rely on local patrons for their trade, and many stores went out of business.

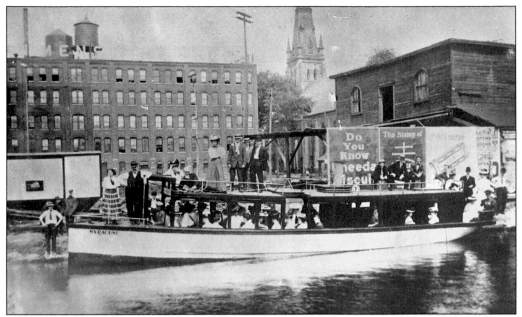

In the early 20th century, Herbert Franklin and John Wilkinson founded the Franklin Motor Car Company in Syracuse. At the height of production, the company employed 5,000 workers and turned out 15,000 cars a year. Shown is a group of Franklin office workers heading off to a picnic on the canal boat *Syracuse c.* 1904. The man on the bow is Tom Kerr, the builder of the boat. His daughter, Mary Kerr Thom, is at his side.

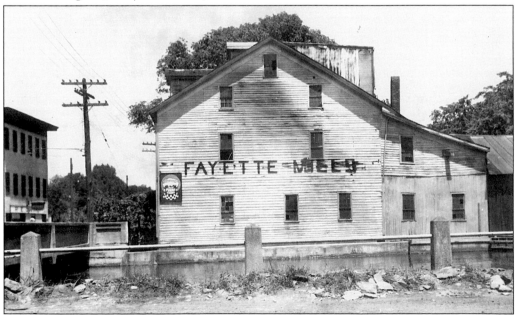

Fayette Mills sits on the banks of the Erie Canal at Waterloo. The town of Waterloo lies immediately to the west of Seneca Falls and is best known as the birthplace of Memorial Day. The idea for what was originally known as Decoration Day was conceived by Waterloo merchant Henry C.E. Wells and was first celebrated on May 30, 1868. The name was changed to Memorial Day in 1882.

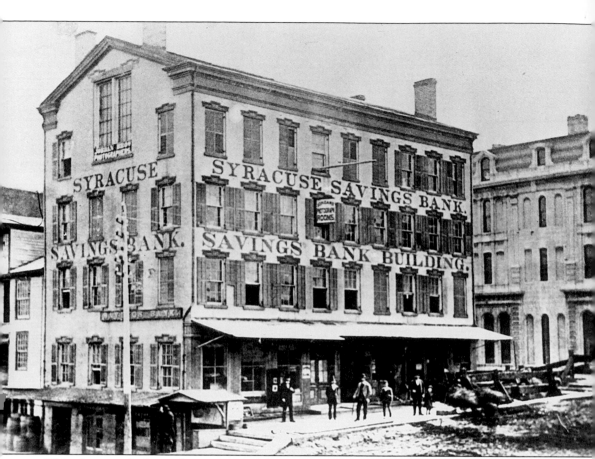

This photograph shows the opening of the Syracuse Savings Bank Building on the site of the former Daily Star Building c. 1850. The Syracuse Savings Bank was incorporated in 1849. The savings bank movement in New York State, championed by Gov. Dewitt Clinton, fostered the growth of commerce and industry by investing in Erie Canal cities and towns.

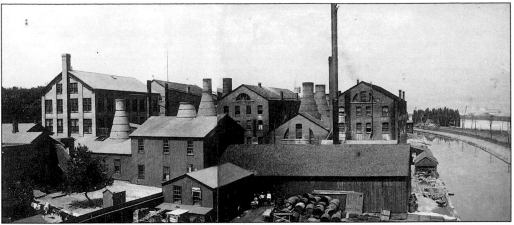

Syracuse china, manufactured by the Onondaga Pottery Company, became famous all over the world. The company built its factory alongside the Erie Canal and used the canal to receive its raw materials and to ship finished goods to market.

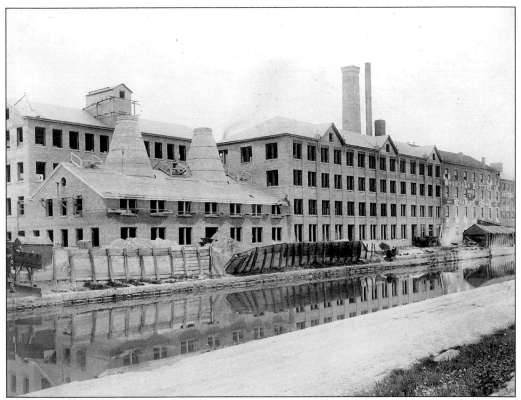

This is a fine view of the Onondaga Pottery Company, on the banks of the Erie Canal. The company, incorporated in 1871, developed the first fine china produced in the United States in 1888. The company changed its name to Syracuse China in 1966 and is still in operation today.

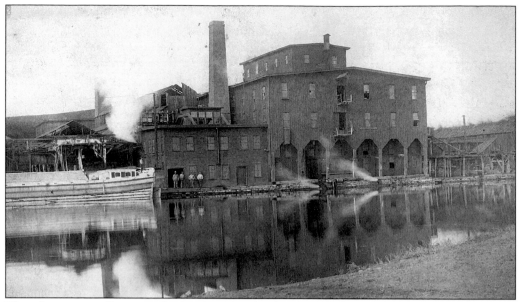

The salt springs in Syracuse, the first known inland source of salt in the United States, hastened the growth of the area. James Geddes, who conducted the first survey of a possible canal route, was a pioneer in the salt industry. Eventually, he was chosen as one of the four principal engineers on the Erie and Champlain Canals. This salt mill was located in the Geddes Basin of the Erie Canal.

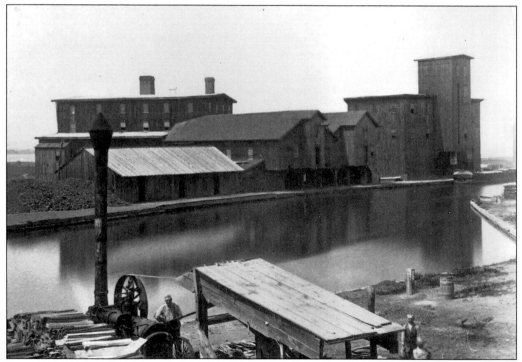

Pictured here is the Excelsior Salt Mill in Syracuse. Thanks in large part to the Erie Canal, 400 million bushels of salt were shipped from Syracuse to all parts of the world. On any given day, 15,000 pounds of salt traveled the canal. The Syracuse salt industry disappeared in 1926.

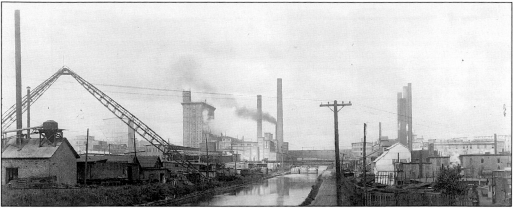

The Solvay Process Company began operation in Syracuse in the 1880s. The company combined limestone from nearby quarries with salt brine to produce synthetic soda ash, which was employed in the manufacture of glass, chemicals, and paper. Shown is the Erie Canal passing through the Solvay Process plant.

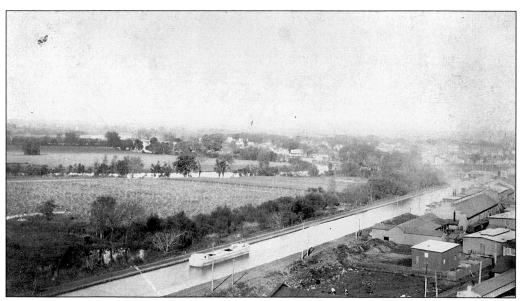

A canal boat leaves the city of Schenectady and passes the Ellis Locomotive Works. This plant was purchased by inventor Thomas Alva Edison and formed the beginnings of the General Electric factory and headquarters, established in 1886.

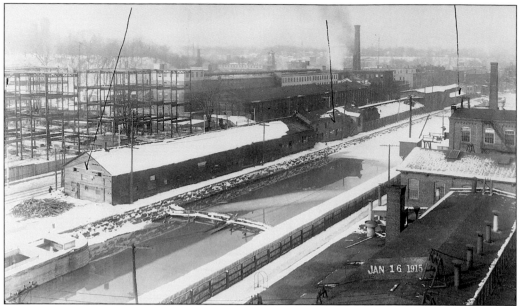

Due in large part to the Erie Canal, major manufacturing plants located in the Mohawk Valley from Utica to Albany. These plants prospered due to the ease of transporting raw materials into and finished products out of the region. This is the Remington Arms plant, on the Erie Canal at Ilion, established in 1826.

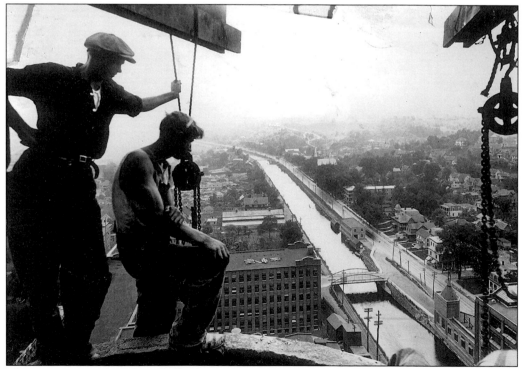

This panorama, taken from high above the Remington Rand tower, offers a fine view of the plant, the canal, and the city of Ilion. The foundation wall of one of the company's buildings served as the berm on the south side of the canal.

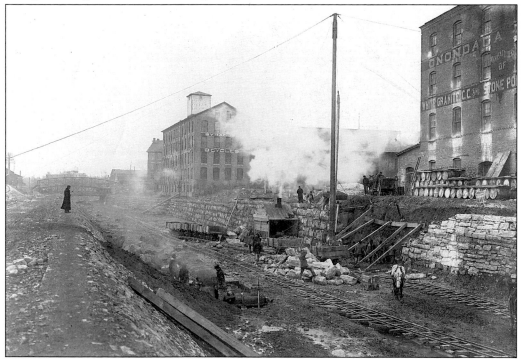

Canal Commissioners of the State of New-York,

To *Jaspar C Smeed* Dr.

To ~~~~ days work on the CANAL, at ~~~ cts. per day, $

To *29 days work at 12 doll/ month* $ *13.38*

Received payment in full, of CHARLES T. WHIPPO, Engineer.

Murray July 22, 1825 *Jaspar C Smeed*

Canal Commissioners of the state of New-York,

To *Asa Belknap* Dr. *26.50*

To *53* days work on the CANAL, at *5*0 cts. per day, $ *26.50*

To ————————————— $

Received payment in full of CHARLES T. WHIPPO, Engineer.

Murray July 25, 1825 *Asa Belknap*

Shown is a page from the State Canal Commissioners' 1825 receipt book. Canal workers often worked from sunrise to sunset, using rudimentary tools, for 50¢ a day. For the construction of the original canal, the state contracted builders, who were generally small contractors, to work on a given length of the canal for a given price.

The McDonald & Sayre Construction Company is making improvements to the Erie Canal on the west side of Syracuse. The Onondaga Pottery Company and Syracuse Bicycle Company factories sit alongside the canal bed. The sign on the Onondaga Pottery building promotes the company's earthenware and porcelain products.

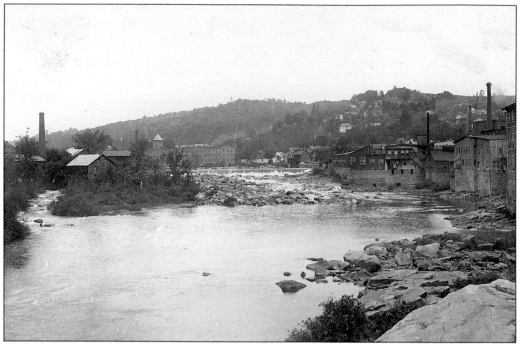

The Mohawk River, flowing through Little Falls Gorge, furnished the waterpower that made Little Falls an industrial center. By 1909, the city had 55 factories employing 4,408 people. The Little Falls Knitting Company is seen in the center of this picture.

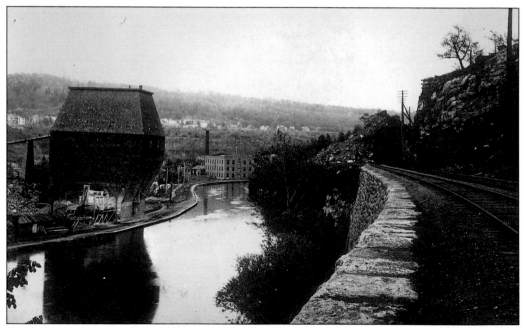

Grain, such as wheat, flaxseed, oats, and corn, was a major portion of the agricultural bounty of New York State. Storehouse operators would buy up grain from the surrounding country for shipment on the Erie Canal. This photograph of the grain elevator at Little Falls also offers a fine view of both the towpath and berm sides of the canal.

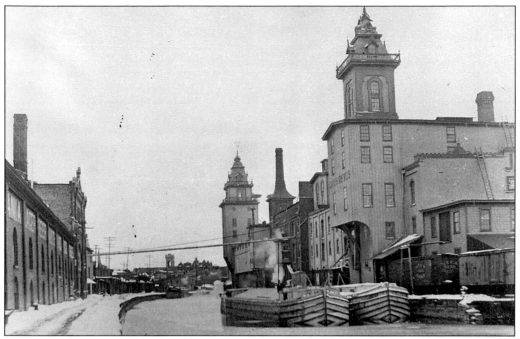

The Empire State Mills, owned by Jacob Amos & Sons of Syracuse, was located on the Erie Canal. Started in 1852, the company moved to the location pictured here in 1861. The company shipped flour and other products via the canal.

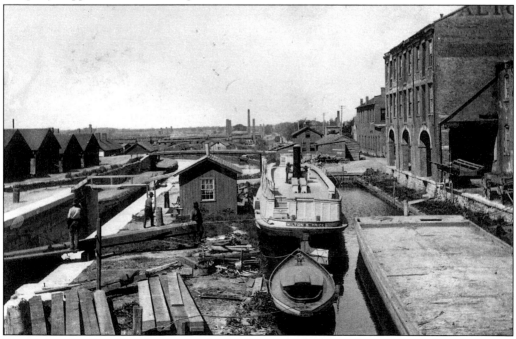

Thanks to the Erie Canal, Syracuse had a thriving brewing industry. The *Milton S. Price* is docked at the Alton & Fleming Brewery next to Lock No. 1 on the Oswego Canal, in Syracuse. Canal boats brought the necessary ingredients for beer brewing to the breweries strategically located on the canal.

This view looks down the Erie Canal from the Fitzhugh Street Bridge at many of Rochester's industrial buildings. The flour-milling industry was a substantial component of the early Rochester economy. The large supply of logs that could be floated down the Genesee River or

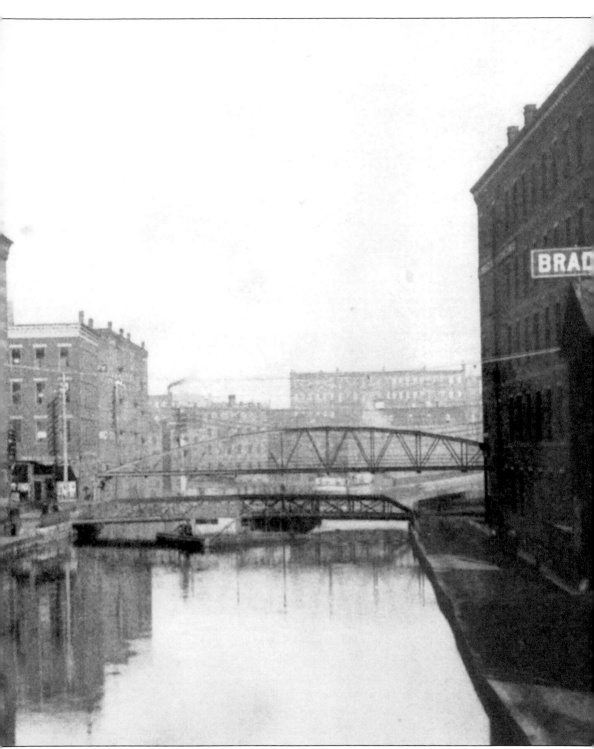

brought across Lake Ontario fostered a lucrative lumber industry, so important to the canal. Rochester, once known at the "Flour City," is now known as the "Flower City."

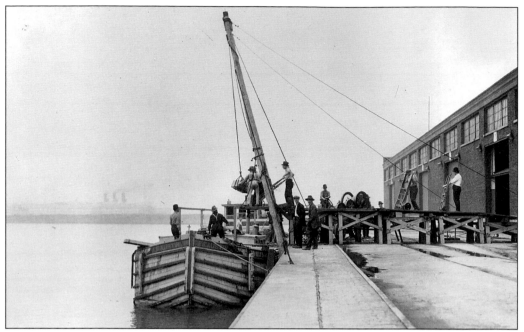

The Erie Canal was the most important factor in the development of Buffalo. During the building of the original canal, Buffalo won out over the nearby village of Black Rock to become the western terminus. In this photograph, men are unloading freight that will be transferred to Lake Erie steamers.

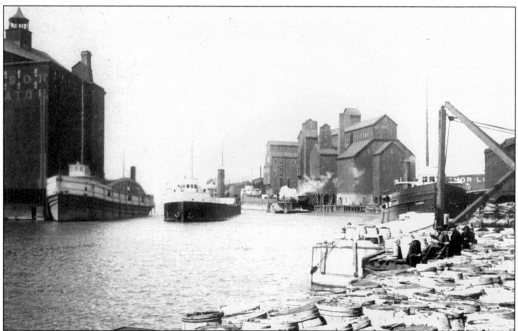

This view of Buffalo harbor, with its enormous storehouses, lakers, canal boats, derricks, and rows upon rows of cargo, indicates the city's commercial importance. The Erie Canal contributed to making Buffalo a great commercial and industrial city. According to the 1910 census, Buffalo was the 10th largest city in the United States.

Five

DISASTERS

Life itself includes many perils. Life on the canal was no different. People who worked the canal daily were presented with the possibility of injury or death, whether on a boat, alongside the canal banks, or on one of the many bridges and other structures. Damage to the canal, such as leaks and cave-ins, was always a possibility and required immediate attention. Builders of the original canal, in order to save money, built bridges only seven and a half feet high. Passengers had to be aware of an oncoming low bridge, thus inspiring the Thomas S. Allen song, "Low Bridge, Everybody Down."

The necessity for quick repairs to the canal brought a sudden influx of temporary employment and construction materials to each disaster area. The interruption of canal traffic caused loss of revenue for the canallers and related businesses, and every effort was made to complete repairs to the canal quickly.

Many stories have been shared; however, few photographic records exist. These next photographs share only a small sample of the tragedies that happened on the Erie Canal. In most of the incidents related, we have attempted to make the reader aware of the final outcome of each difficulty.

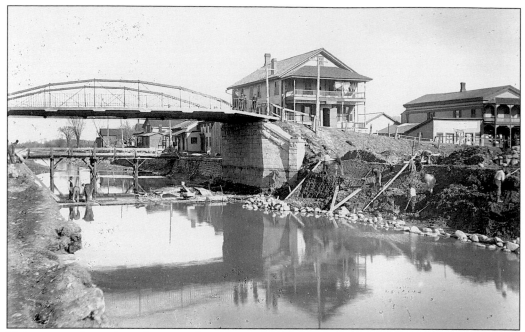

This cave-in has taken place on the canal at Jordan. Men are shoring up the berm in steps before adding stones to stabilize the sloping wall. Another temporary bridge has been built for the town. This indicates the importance of local commerce during the disruption of canal traffic.

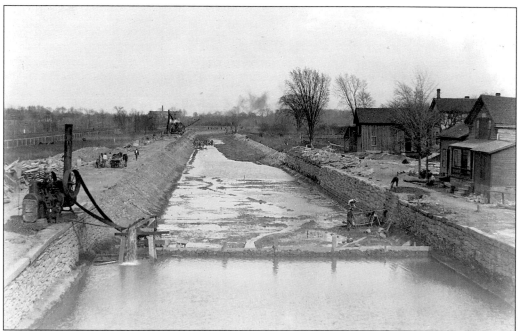

This companion photograph, taken looking east from the Memphis Bridge, in Jordan, shows a cofferdam, a temporary enclosing dam, built around a work site and pumped dry to permit work to be done on the canal structure. A pile driver can be seen in the background on the towpath side.

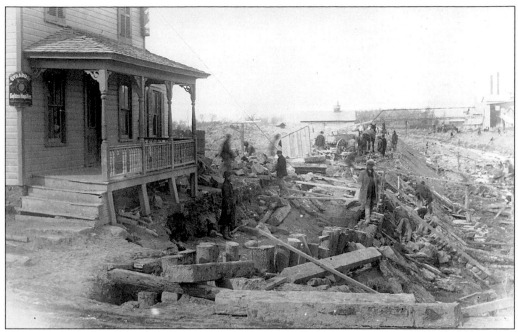

The scene at Dwyer's Hotel, in Herkimer, illustrates the problem of cave-ins along the canal. To facilitate getting the canal back in action, many men were employed to construct pilings and a sloped wall in front of the hotel. Horses and wagons were also part of the work force.

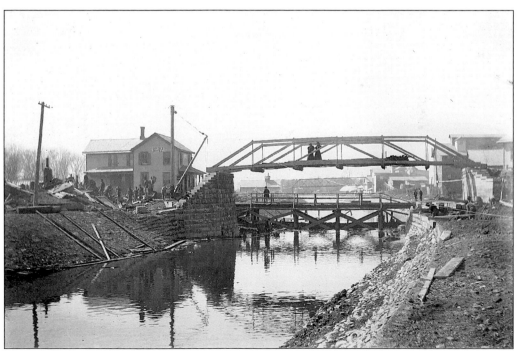

This later photograph taken at Dwyer's Hotel shows that, to allow townspeople access to the other side, a temporary bridge has been constructed while repairs are made to the canal. Water has partially filled the channel.

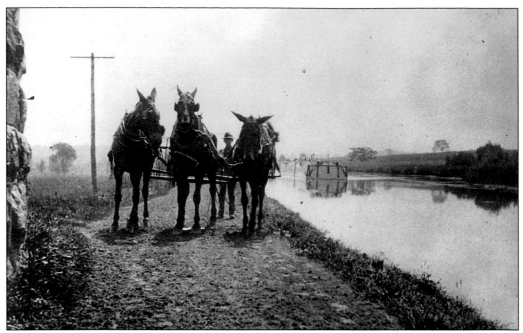

The hoggee's job was not without its risks. There is a story of a 19-year-old hoggee in Jordan who was seriously injured when the line to his team was caught under another boat. In an effort to save the team from being drawn into the canal, he unsnapped the hook and line, which then flew back and struck him in the abdomen.

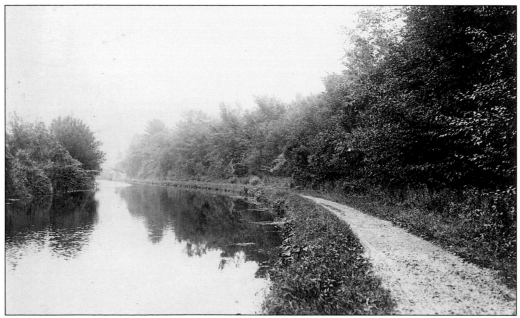

Leaks were the enemy of the canal. Even the smallest leak in the canal's earthen wall could enlarge and wash out an entire section. Muskrats tunneling into the banks were a common cause of leaks. A towpath master was responsible for a 10-mile section of canal and towpath. He carried a sack of manure and hay to plug holes and small leaks. It was the responsibility of everyone using the canal to keep repair crews informed of problems.

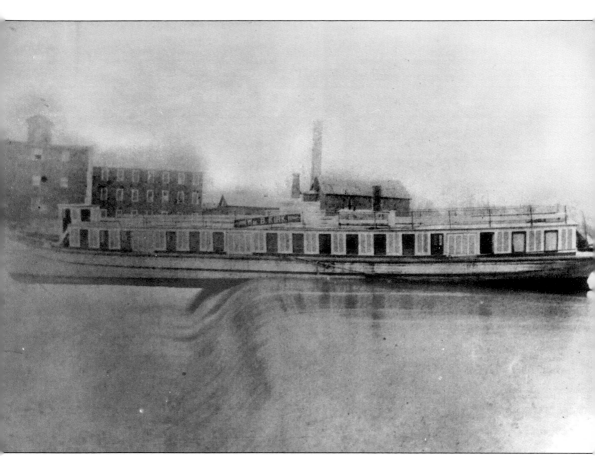

The *Wm. B. Kirk* rests on the Court Street Dam, in Rochester. Apparently the boat had come loose from its moorings and had drifted down the Genesee River to this very precarious position. (Courtesy of Museum of Arts and Sciences, Rochester.)

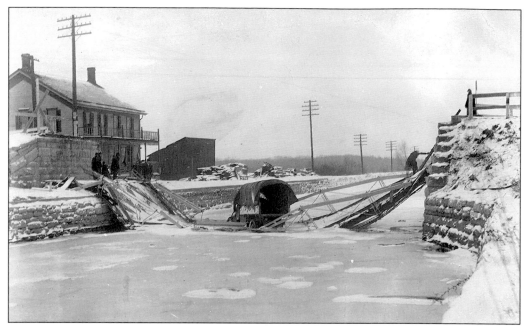

Bridges along the canal were well built, continuously used, and finally abused. This group of photographs tells the story of a bridge collapse near Syracuse. An overloaded truck attempted to cross an Erie Canal bridge. It reached the midpoint of the bridge and plunged with the bridge into the somewhat drained, though icy, waters of the canal.

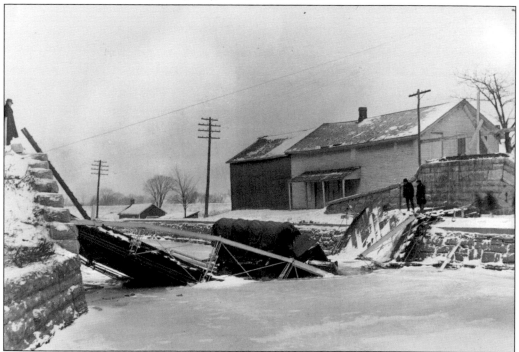

The views of the collapsed bridge, taken looking both east and west, show the durability of the limestone abutments. Luckily the bridge collapsed during the winter months, allowing for its reconstruction to be completed before the spring's resumed canal traffic.

The next two photographs, taken from opposite sides of the bridge, show the progress of bridge reconstruction. Notice the danger signs and construction debris in this view. The sign above the bridge lists the maximum capacity of the new bridge as 12 tons.

The photographer of this replacement bridge took pains to include the danger signs on each side road approaching the bridge construction site. Does it make you think of all the signage and lighting necessary at today's bridge construction sites?

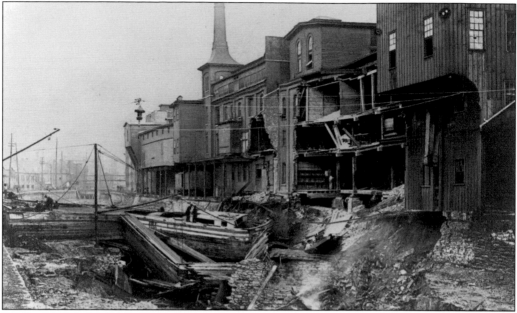

Breaks in the canal were devastating for the area in which they occurred, as well as for the canallers and businesses involved. One such break took place in Syracuse in 1907, at the point where the canal crossed Onondaga Creek.

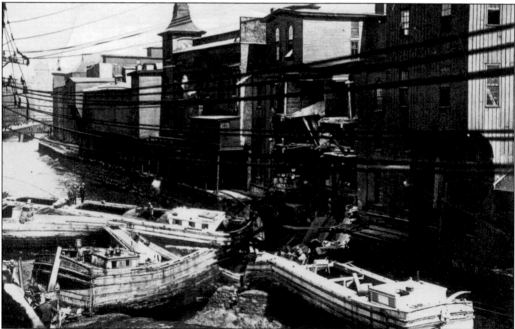

On July 30, 1907, the keystone in the center arch of the canal aqueduct over Onondaga Creek suddenly gave way. The water from the entire Syracuse level of the canal, a seven-mile stretch, gushed into Onondaga Creek, creating a whirlpool. Men working at Crouse Hinds Company, three blocks away, were heard to say, "It's flowing upstream." Boats docked at the nearby Syracuse Lighting Company and the Greenway Brewery were tossed like matchboxes, and they plugged the channel.

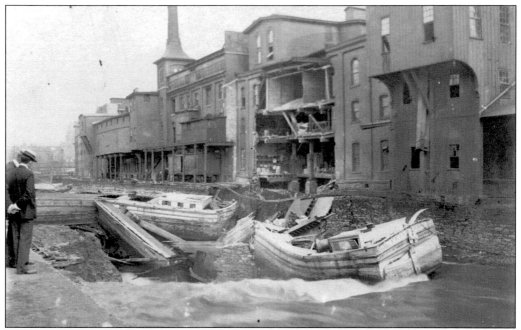

The foundation of the Jacob Amos Feed and Flour Mill was eroded, and its canal-side wall collapsed, tossing 500 barrels of flour into the water. Bricks and lumber added to the turbulent mix. The next day, the wall of the Greenway Brewery on the towpath side fell into the canal. The canal became a mass of mud and rubble, which took two months to repair.

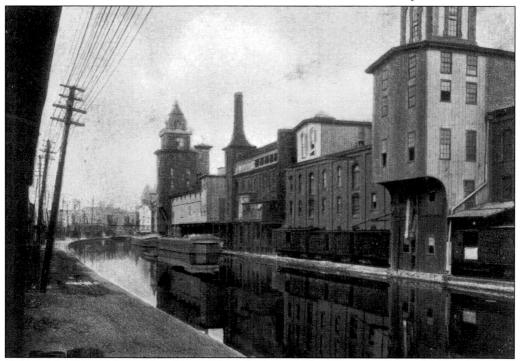

Calm returned on September 20, 1907, with the repairs to the canal completed. Canal-side businesses and canal traffic returned to normal.

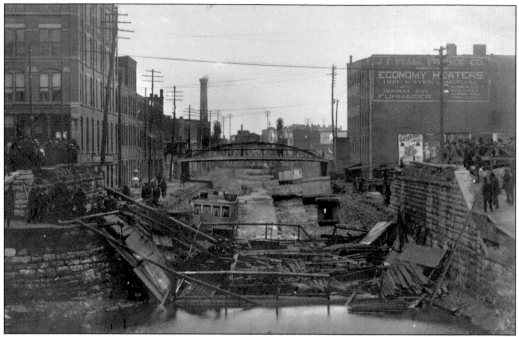

This bridge collapse was at the James Street Bridge, over the Oswego Canal in Syracuse. The first view is looking north at the debris in the canal, the houseboat in the canal, and the large crowd of onlookers on both sides of the bridge. Often, accounts of a bridge's collapse did not list injuries or casualties that may have occurred.

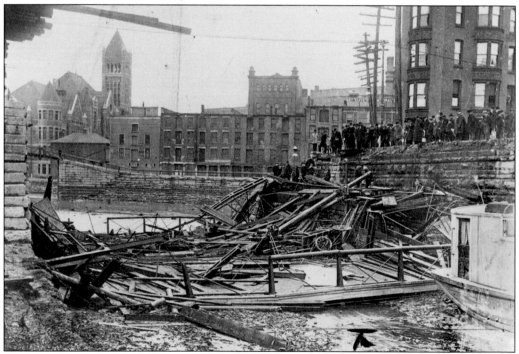

The second view, looking south toward Syracuse City Hall, shows how close the houseboat came to the disaster. You can also see the Erie Canal towpath and change bridge in the background.

Six

REMNANTS OF
PAST GLORIES

As the 20th and 21st centuries have dawned, new technology in construction equipment and in cargo and passenger transportation has changed the path of the old Erie Canal. The New York State Barge Canal, opened in 1918, and now used primarily for recreation, utilizes New York's natural waterways as often as possible and, thus, large sections of the original Erie Canal and the enlarged canal have been left and often forgotten.

Gone are the stump pullers that, with horsepower and manpower, ripped trees, stump and all, from the path of the canal. Gone are the canal-side general stores that served the boatmen and their families. Gone are the line barns, every 10 to 12 miles, where fresh mules or horses waited to relieve tow teams. Gone are the locktenders' houses and gardens, where news of the day was passed to the canallers. Gone are the dry docks where, in a busy year on the canal, 400 to 500 boats were repaired. Canal boat basins have been replaced by today's crowded marinas. The panoramic view of the countryside seen from slow-moving canal boats has been replaced by the quick glance out of the fast-moving automobiles' windows.

The reader is taken through some of the lost and forgotten treasures of the old Erie. In some localities, individuals and government entities with foresight and an appreciation of history have reclaimed these areas for use as parks, trails, and interpretive centers. Some only have signage to draw travelers' attention.

Many thanks to the photographers who captured the life of the Erie Canal on film and to those who, through the years, have shared the photographs with the museum and the reader.

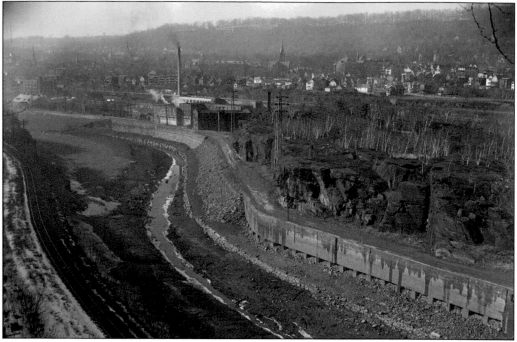

Shown is the empty channel of the Erie Canal at Little Falls. Little Falls traffic originally required a mile portage around its rapids. The Erie opened a waterway route through this area. Now, the channel is only a small reminder of the hustle and bustle of yesteryear.

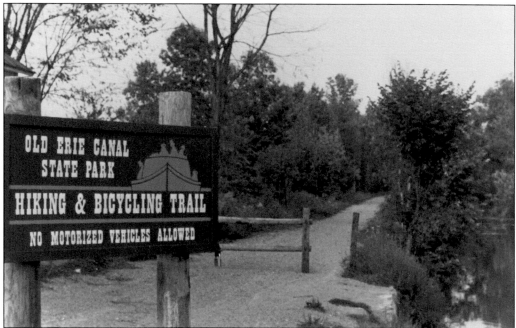

The towpath that once carried mules, horses, and hoggees now serves as a recreation trail in many parts of upstate New York. The Old Erie Canal State Park is a 36-mile-long linear park running from Dewitt, near Syracuse, to Rome. The park provides opportunities for picnicking, hiking, bicycling, canoeing, fishing, and snowmobiling.

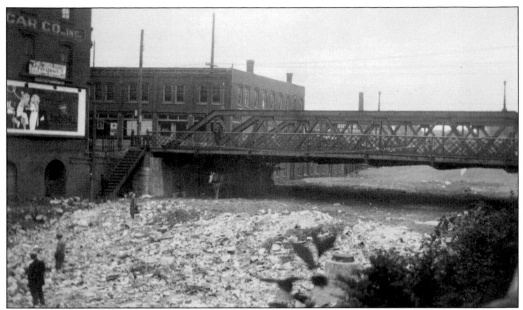

This photograph shows the remains of the canal in Rome. Construction of the original Erie Canal began at Rome on July 4, 1817. Benjamin Wright, a resident of the city, was given responsibility, along with James Geddes, for canal construction. Wright eventually became known as the Father of American Engineering.

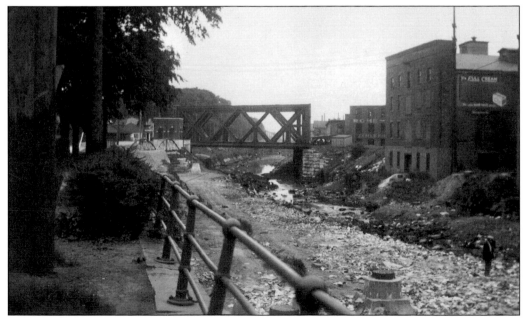

By the end of 1817, a 15-mile-long ditch—40 feet wide at the top, 28 feet wide at the bottom, and 4 feet deep—had been dug. By late 1819, the first section of the canal from Rome had been opened. Today, what once was the Erie Canal in Rome is now Black River Boulevard.

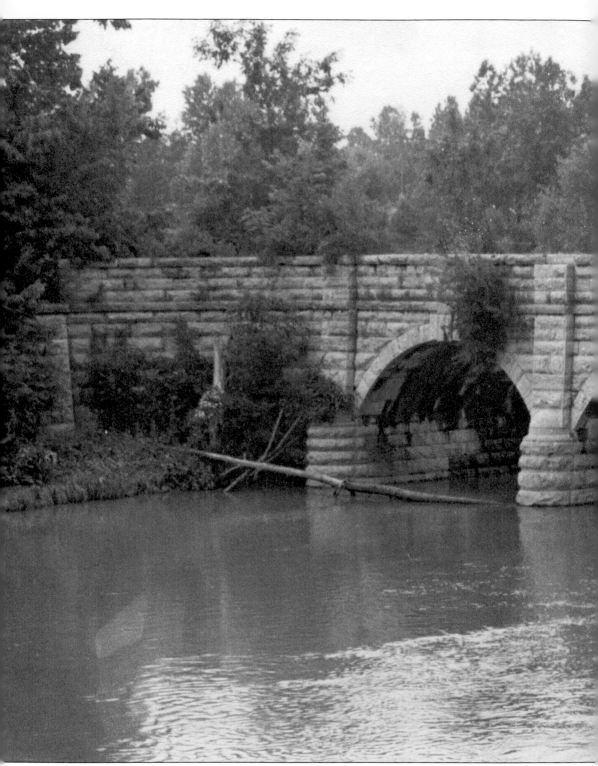

This picture of the aqueduct in Palmyra reminds us of the economic stimulus the completion of the Erie Canal brought to each village and town along its route. The aqueduct in Palmyra that

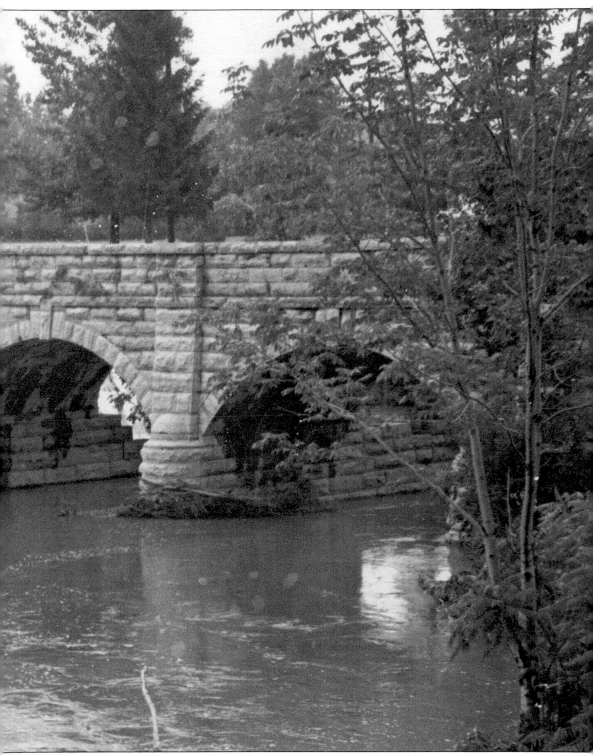

brought the canal over Ganargua Creek is now the location of Aqueduct Park.

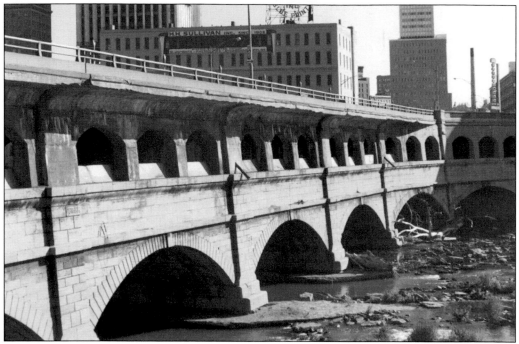

The Genesee River Aqueduct in Rochester, seen here holding the Broad Street Bridge, is the replacement for the original aqueduct built in 1823, a little to the north. Completed in 1842, it was 45 feet wide, which allowed for two-way traffic. Both the original aqueduct and this aqueduct were constructed of solid masonry.

This view of the Limestone Creek Aqueduct clearly captures the stonework required to build these structures. There were 18 aqueducts on the original canal. This view from the towpath shows the arches, the stone piers, and the stone abutments. The trough that carried the canal over Limestone Creek and the towpath cannot be seen from this angle.

This fine view of the Limestone Creek Aqueduct offers one more opportunity to marvel at the stonework necessary to take the canal across the creek. This aqueduct is just to the east of the Butternut Creek Aqueduct, in Dewitt.

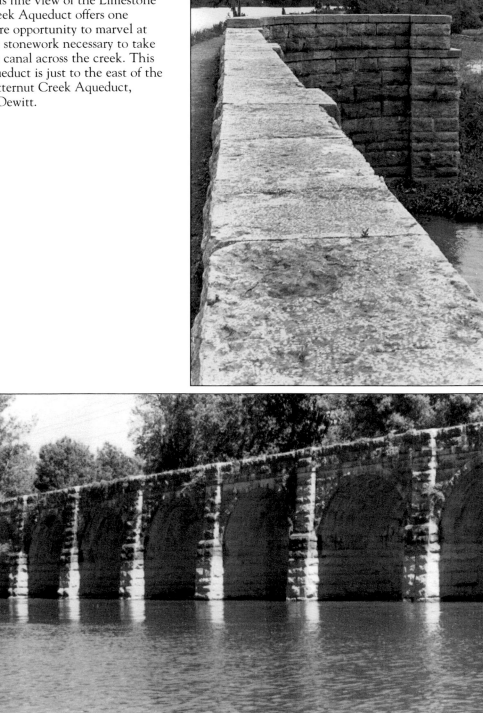

The Montezuma Aqueduct illustrates the staying power of the structures that were part of the Erie Canal. It has been allowed to remain, and the vegetation in the area has begun using it as a trellis, until such time as it is reclaimed.

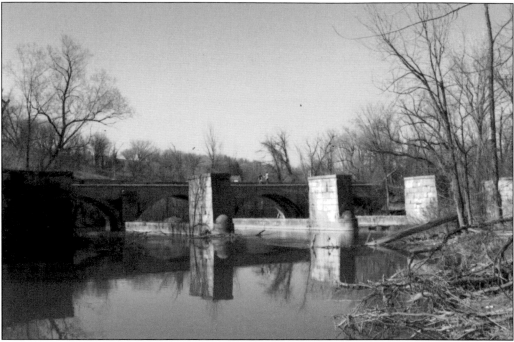

This view looks north down Nine Mile Creek at the Camillus Aqueduct, spanning the creek. At 144 feet, this was the sixth longest aqueduct in the middle section of the Erie Canal. By the end of the 19th century, there were 32 aqueducts on the enlarged canal.

This view is looking west along the towpath on the Camillus Aqueduct, over Nine Mile Creek. Today, the aqueduct is undergoing restoration to reintroduce some of yesterday's wonders.

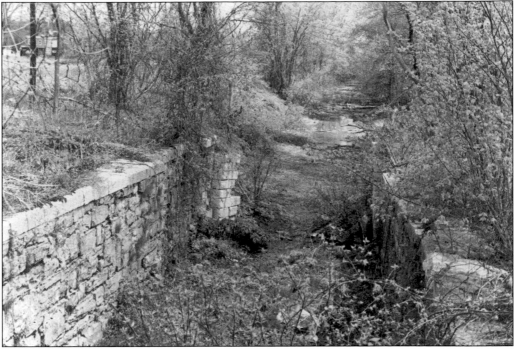

With the building of the enlarged Erie Canal, some sections of the original canal were abandoned. This is a view of the remains of the 90-foot-long Lock 20, built in 1822 at Fort Hunter, west of Amsterdam.

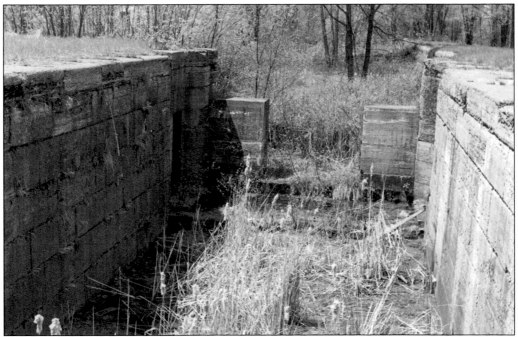

This view shows the remains of a lock chamber at Fort Hunter. Some of the double locks on the Erie Canal enlargement cost $80,000 to $100,000 to construct. These meticulously engineered and constructed locks served until the last days of the old Erie Canal.

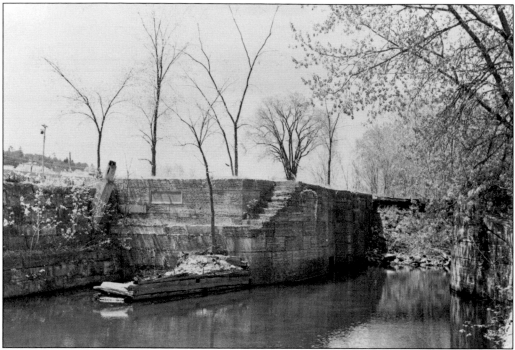

This is a photograph of Lock 28, also known as Yankee Hill Lock, prior to its reconstruction and preservation in 1989.

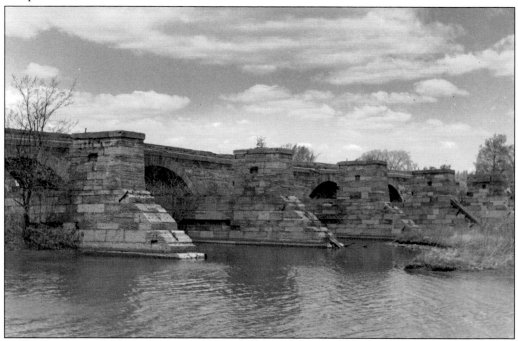

At Fort Hunter a stone-arched aqueduct, completed in 1842 and 624 feet long, crosses Schoharie Creek at the point where the creek enters the Mohawk River. This aqueduct replaced a bridge and slack water pond system that was about 1,000 feet to the south. Six of the 14 arches remain. It is a Registered Historic Landmark.

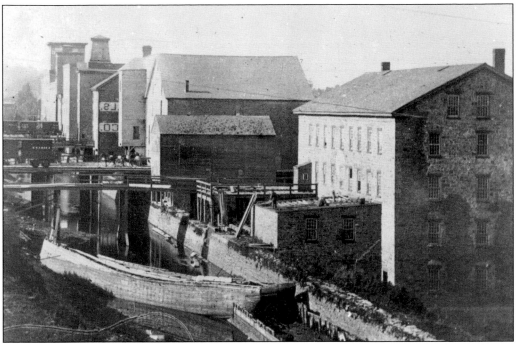

The canal boat seen in this reverse photograph is left to decay, no longer able to carry the cargo to meet the demands of the 20th-century economy.

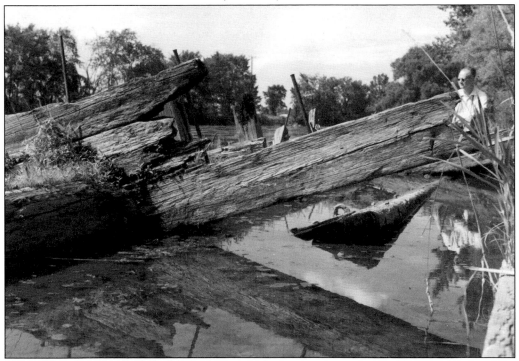

A man investigates the deteriorating remains of a barge in the Fayetteville Feeder. The craftsmanship of each boatbuilder was identifiable in his boats. Each prided himself on the durability and longevity of his boats.

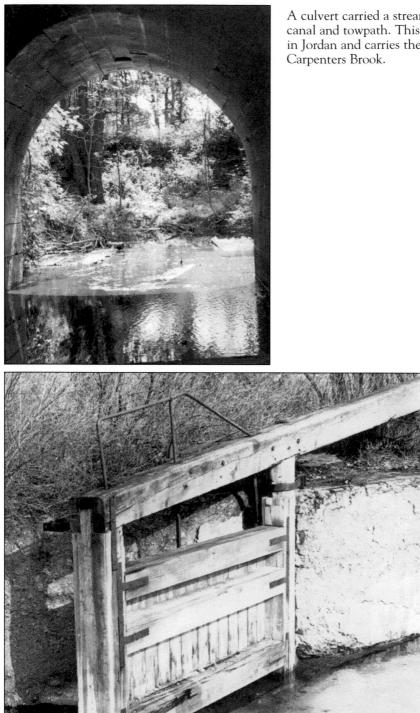

A culvert carried a stream under the canal and towpath. This culvert is located in Jordan and carries the Erie Canal over Carpenters Brook.

This lock gate is typical of the wooden gates used on the Erie Canal. There were two gates at each end of the lock; one leaf of each was placed against the other at an angle, with the angle pointing upstream. The gates at either end of the lock could be closed, holding back the flow of water.

126

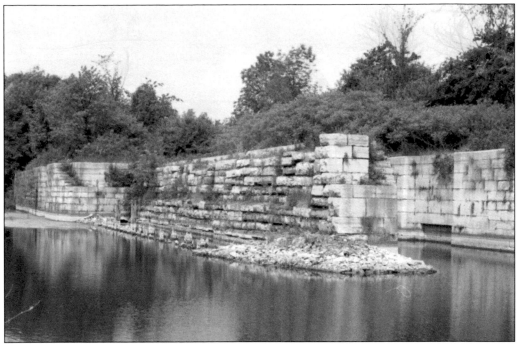

This is Lock Berlin No. 54, on Route 31, Gantz Road, in Lyons. It is an example of another canal structure that is no longer in use. Because locks were constructed of both stone and wood, it is not surprising that only the stone structures remain.

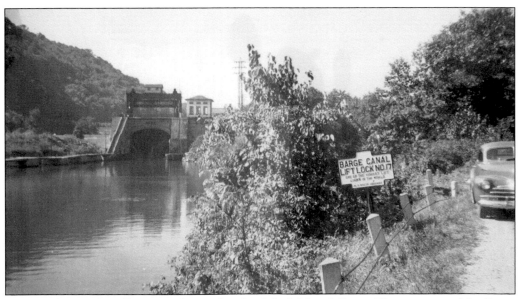

The canal at Little Falls ran on the south side of the Mohawk River. This is a view of the Barge Canal's Lift Lock No. 17, at Little Falls. On the old Erie Canal, there were two locks at Little Falls and five more just a mile above this lock. Today, locks remain a fascination for many. Notice the parked car. Is the occupant taking advantage of the nearby scenery?

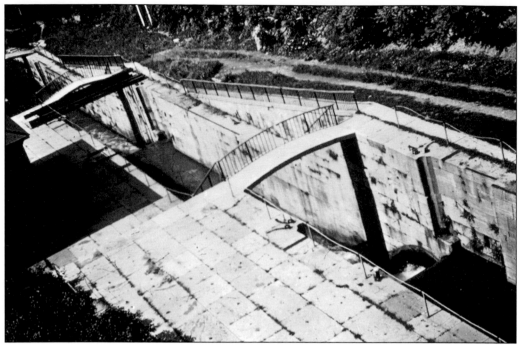

A thousand men risked their lives to cut through the Niagara Escarpment at Lockport to build five eastward-bound and five westward-bound locks on the original canal. This view shows one set of those locks, now quiet against the countryside.

SITE OF OLD
ERIE CANAL LOCK
BUILT 1851

This photograph was taken from the New York State Thruway near Port Byron. The thruway is one of today's east-west routes for both passengers and cargo. While you travel the modern superhighway, the sign points you in the direction of the remains of one of yesterday's locks on the old Erie Canal.